MAN RAY

1890-1976

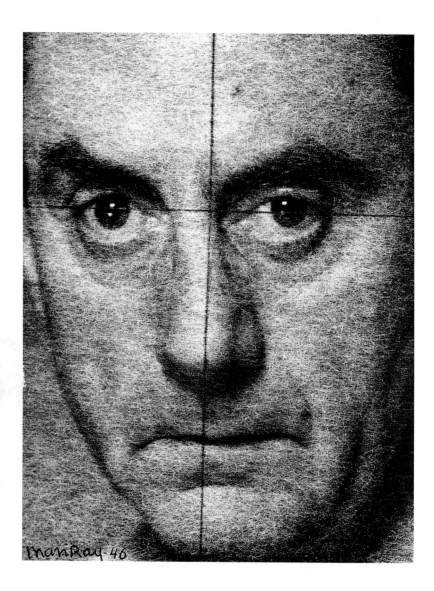

Self-Portrait
1946

MAN RAY

ESSAY BY EMMANUELLE DE L'ECOTAIS

1890-1976

A PERSONAL PORTRAIT BY ANDRÉ BRETON

EDITED BY MANFRED HEITING

TASCHEN

KÖLN LONDON MADRID NEW YORK PARIS TOKYO

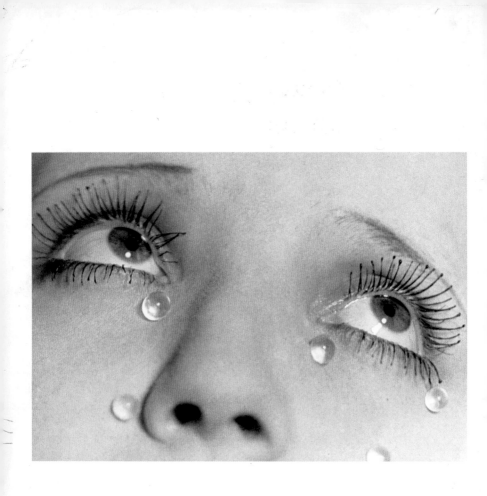

Les Larmes
c. 1932

Contents
Inhalt
Sommaire

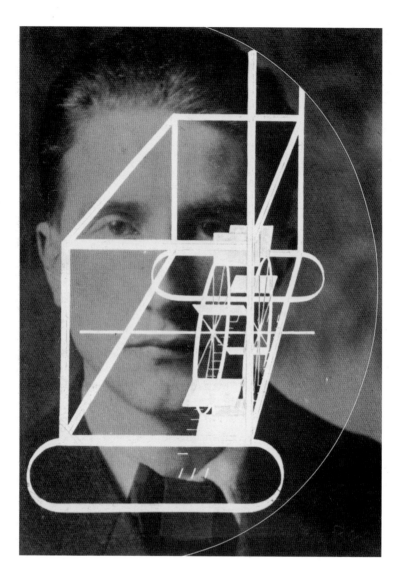

Marcel Duchamp et sa glissière contenant un moulin à eau [en métaux voisins]
c. 1923

Self-Portrait
1924

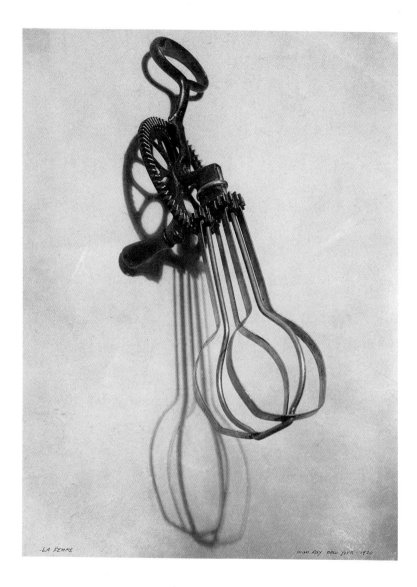

La femme
1920

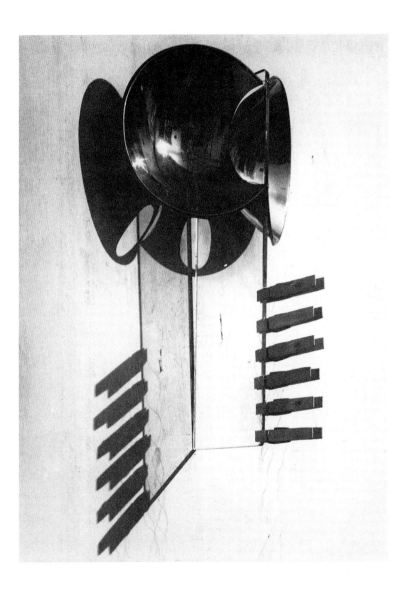

Integration of Shadows
1919

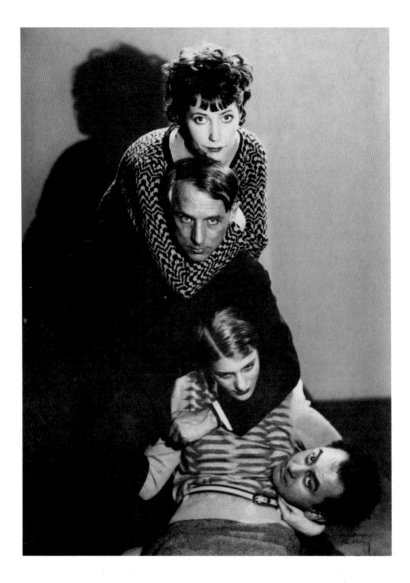

Marie-Berthe Aurenche, Max Ernst, Lee Miller, Man Ray
c. 1932

On Man Ray

ANDRÉ BRETON

Extract from "Le Surréalisme et la Peinture", Paris 1927
Translated from the French by Simon Watson Taylor[1]

Almost at the same time as Max Ernst, but in a different and, at first
sight, almost opposite spirit, Man Ray also derived his initial impetus
from photographic precepts. But far from entrusting himself to photog-
raphy's avowed aims and making use, after the event, of the common
ground of representation that it proposed, Man Ray has applied himself
vigorously to the task of stripping it of its positive nature, of forcing it to
abandon its arrogant air and pretentious claims. If, as Ramón Lulle has
stated, "the mirror is a diaphanous body disposed to receive all the fig-
ures that are presented to it", then one cannot say as much for the photo-
graphic plate, which begins by requiring that these figures assume favor-
able attitudes, or goes even farther and takes them unawares at their most
fugitive moments. These same considerations apply, indeed, to the
taking of cinematographic images, which tend to compromise these fig-
ures not only in an inanimate state but also in motion. The photographic
print, considered in isolation, is certainly permeated with an emotive
value that makes it a supremely precious article of exchange [and when
will all the books that are worth anything stop being illustrated with dra-
wings and appear only with photographs?] Nevertheless, despite the fact
that it is endowed with a special power of suggestion, it is not in the final
analysis the faithful image that we aim to retain of something that will
soon be gone for ever. At a time when painting, far outdistanced by pho-
tography in the pure and simple imitation of actual things, was posing to
itself the problem of its reason for existence and was resolving the prob-
lem in the manner we have described, it was most necessary for someone
to come forward who should be not only an accomplished technician of
photography but also an outstanding painter; someone who should, on
the one hand, assign to photography the exact limits of the role that it
can legitimately claim to play, and on the other hand, guide it towards
other ends than those for which it appears to have been created – in par-

ticular, the thorough exploration on its own behalf, within the limits of its resources, of that region which painting imagined it was going to be able to keep all to itself. It was the great good fortune of Man Ray to be that man. Indeed I would consider it fruitless to attempt to divide his artistic production into photographic portraits, photographs inappropriately called 'abstract', and pictorial works properly so called. I know only too well that these three kinds of expression, signed with his name and fulfilling the same spiritual mission, are all bordered at their outer limits by the same conspicuous or inconspicuous halo.

The very elegant, very beautiful women who expose their tresses night and day to the fierce lights in Man Ray's studio are certainly not aware that they are taking part in any kind of demonstration. How astonished they would be if I told them that they are participating for exactly the same reasons as a quartz gun, a bunch of keys, hoar-frost or fern! The pearl necklace slips from the naked shoulders on to the white sand, where a ray of sunlight whisks it away together with other elements near by. What was merely adornment and what was anything but adornment are abandoned simultaneously to the declaration of the shadows, the justice of the shadows. The caves are full of roses. The ordinary preparation to which one surface will shortly be submitted will not differ in the least from the preparation being applied to the other surface so that the most beautiful features in the world may be created on it. The two images live and die from the same trembling, the same hour, the same lost or intercepted glimmers of light. They are both nearly always so perfect that it is very difficult to realize that they are not on the same plane: one would have thought that they are as necessary to each other as is that which touches to that which is touched. Are they golden-haired or angel-haired? How can we distinguish the wax hand from the real hand?

For whoever is expert enough to navigate the ship of photography safely through the bewildering eddies of images, there is the whole of life to recapture as if one were running a film backwards, as if one were to be confronted suddenly by an ideal camera in front of which to pose Napoleon, after discovering his footprints on certain objects.

1] *The English translation* Surrealism and Painting *was published 1972 by Mcdonald and Co., London. Original French publication: André Breton, "Le Surréalisme et la Peinture", in: La Révolution Surréaliste, no. 9–10, Paris, 1. October 1927, pp. 41–42.*

Man Ray

EMMANUELLE
DE L'ECOTAIS

Creator of Surrealist Photography

The period Man Ray spent in Paris [1921–1940] proved to be his most interesting, work-wise. It was there that the originality of his art developed, and where it had the greatest repercussions. Paris had become the hub of the art world: the Dada movement, founded in Zurich in 1916, had established a base in the French capital, mainly owing to Tristan Tzara's arrival there. Man Ray, whose art had failed to blossom in the United States, saw Paris as the promised land. His closest friend in America was a Frenchman: none other than Marcel Duchamp. Duchamp took Man Ray around with him, introducing him to everyone who would in due course be instrumental in the development of his work and career.

Thus, the first person to exert a strong influence on Man Ray's work was Marcel Duchamp some years before Man Ray set off for Paris. They actually met in 1915, in Ridgefield, New Jersey, striking up a friendship immediately, despite the language barrier between them. Duchamp was driven by a desire to achieve "that precision painting and that beauty of indifference" which prompted him to stop painting altogether, so he found in Man Ray and his burgeoning interest in photography, both a friend and a crucial associate. Man Ray himself then strove to develop his painting towards a flattened style, probably as a result of discovering photography. His aerographs [since 1917], which were spray paintings, resulted from the same Duchampian principle that involved classic painting techniques. With his new enthusiasm for photography, Man Ray discovered a convinced supporter in Duchamp. Or, more accurately, both men together discovered in photography an ideal means of creative work, satisfying in them that "precision optics" requirement which would give rise, with Duchamp, to different research projects involving optics [*Rotary Glass Plates*, 1920], as well as to certain parts of the *Large Glass* [1915–1923], such as *Draft Pistons* [1914], the photographic production of which was, we know, done at the suggestion of Man Ray.

Take, for example, the creation of Rrose Sélavy, by Duchamp. Most probably, the very idea of this imposture sprang to Duchamp's mind because there was a photographer among his circle of friends. What better than a photograph to lend reality to, underpin, and certify the authenticity of a fact, an event, or the existence of a person? In a reciprocal way, it is possible to see in Man Ray's research into shadows [*Integration of Shadows*, 1919, ill. p. 9] and machines [*La femme*, 1920, ill. p. 8] an influence stemming from Duchamp's work on cast shadows and the mechanics of the *Large Glass*.

Marcel Duchamp and Man Ray thus overlap on one point: for an artist, it is the expression of an idea that is of paramount importance, the technique used to do so being not an end in itself, but a means of achieving that end: "My aim was to turn inwards, rather than outwards," wrote Duchamp. And "… from this viewpoint, I came to think that an artist could use any old thing […] to express what he wanted to say."[1] Both artists "stood back from the physical act of painting"[2]. Duchamp explained that he wanted "to get back to absolutely dry drawing, to the composition of a dry art", the best example of which was the "mechanical drawing"[3]. And this is precisely what Man Ray did with his aerographs, and with the glass plates and photography.

This perfect mutual understanding would prompt Man Ray to follow his friend to Paris. The miserable failure of the magazine *New York Dada*, which they co-edited in New York, merely confirmed the American's hunch: only the French capital was "ready" to accommodate his deeply Dada spirit.

In Paris, on the evening of 22 July 1921, Duchamp introduced Man Ray to the entire Dada group: André Breton, Jacques Rigaut, Louis Aragon, Paul Eluard and his wife Gala, Théodore Fraenkel, and Philippe Soupault. The most surprising thing for Man Ray was that there wasn't a single painter among them. They were all poets and writers. None of these artists actually had any influence on Man Ray's work. André Breton, on the other hand, who published the magazine *Littérature*, saw right away how Man Ray could be of use to him. As a photographer, he quickly became the publisher's indispensable right-hand

1] *Marcel Duchamp, Interview with James Johnson Sweeney, quoted by Michel Sanouillet, in:* Duchamp du signe, *nouvelle édition, Paris, Flammarion, 1975, p. 171.*

2] *Marcel Duchamp,* op. cit., p. 171.

3] *Marcel Duchamp,* op. cit., p. 179.

man. And Breton called him up regularly, dispatching him to artists' studios to photograph the works he wanted to reproduce in his magazine. Man Ray was to make the most of this job in two ways: firstly, he used each session to do a portrait photograph of the artist in question; secondly, by way of exchange, he asked André Breton, who wasn't paying him, to reproduce his own works in the magazine. His acknowledged experience as a portraitist [he had won a prize for his portrait of Berenice Abbott at the *Fifteenth Annual Exhibition of Photographs* held in Philadelphia in March 1921], combined with word-of-mouth recommendations, was so effective that in no time Man Ray had met all the Parisian personalities of the day. And each one led to other customers: Gertrude Stein introduced him to Pablo Picasso and Georges Braque; Jean Cocteau introduced him to all the affluent aristocrats, who were forever looking for an original portraitist. Little by little, Man Ray's studio even became a place of pilgrimage for foreigners in Paris. In the 1920s, portraits of high-society Parisian ladies were often used as fashion photographs, so that in time Man Ray made contact with the couturier Paul Poiret, and in 1924 started to work regularly for *Vogue*. His success was all the greater because, in tandem, he published his more personal works in *Littérature, Les Feuilles Libres, The Little Review* and even *Vanity Fair*.

What really triggered this success was his discovery of rayography in late 1921 or early 1922. Man Ray became the champion of photographic manipulation, producing effects that, in the eyes of the Parisian public, enhanced creative photography and raised it above photography in its purest form. Running counter to other photographers of the day, who were keen to elevate Modern Man through modern technology without 'doctoring' images, Man Ray used photography like any other medium. He reframed, retouched, negative printed, reversed and inverted pictures[4], and he even took camera-less photographs. In a nutshell, Man Ray invented Surrealist photography.

What is generally known as a "photogram" or "rayograph" is a simple process in which objects are put directly on photographic paper, and then exposed to light for a few seconds. By then developing the paper in a normal way, a reverse image is obtained. Man Ray related how

4] *On this subject, cf.* La photographie à l'envers, *Musée national d'art moderne, Centre Georges Pompidou, Paris [Le Seuil]* 1998. *English edition:* Man Ray, Photography and its Double, *New York [Gingko Press],* 1998.

5] *Man Ray, "L'Âge de la Lumière", in:* Mino-taure, 1933, nffl 3-4, *p.* 1.

6] *From 1834-35 onward, William Henry Fox Tal-bot [1800-1877] produced imprints of objects on sil-ver chloride photographic paper which he called "photogenic drawings".*

7] *Floris M. Neusüss and Renate Heyne, in:* Lász-ló Moholy-Nagy, com-positions lumineuses, 1922-1943, *Paris, Musée national d'art moderne, Centre Georges Pompidou, 1995, pp.* 14-15.

8] Op. cit.

he discovered this procedure during a darkroom session, when some fashion photographs were being developed for Paul Poiret. His explanations, however, were more amusing than they were persuasive. Man Ray harbored a definite wish to hide his creative processes, driven by his deeply held conviction that the important thing was not the technique used, but the final work. Man Ray even said that "a certain contempt for the physical means of expressing an idea is vital for its best possible execution"[5]. So the anecdote about this chance discovery is of little relevance. On the other hand, we do know that Tristan Tzara, then a close friend of Man Ray, had in his possession a collection of 'schadographs' produced in about 1918–1919 by Christian Schad [1894–1982]. This latter was part of the Zurich Dada group, and had himself drawn inspiration from the early works of Henry Fox Talbot[6]. Christian Schad used paper which darkened directly: "[a] surface with very low sensitivity, which could be prepared on sight, in reduced light, and which was then exposed to the sun. The advantage of this procedure was that it required no darkroom."[7] Man Ray, for his part, produced rayographs in a darkroom: "It's only after having been developed and then fixed that the print could be looked at in full daylight. The main reason for this choice was probably based on the possibility of altering, as required, the intensity and direction of the light."[8] What is more, Christian Schad only placed paper cutouts and flat objects on the sensitive paper. In so doing, he produced pictures very much akin to Cubist collages. For his part, Man Ray used all manner of three-dimensional objects, and glass items in particular; the shadows cast by them, and their translucent nature, made it possible to obtain different values in the resulting blacks and whites. The fact that there were Christian Schad prints in the collection of a close friend of Man Ray may lead us to suppose that he did not 'discover' this technique by chance, as he explained it, but that he drew on Christian Schad's research to create a new form of expression.

Man Ray's laboratory experiments are in keeping with his earlier research. In the pictures he produced in New York, Man Ray had shown his concern for expressing the life of objects, their independence, and their capacity to mean something more than they would when seen as simple products, manufactured for a specific purpose. *La femme* [1920,

ill. p. 8] is an eggbeater whose significance is transformed by way of the titles. There are other versions with the title *Man* [1918] or *L'Homme.* The rayograph proceeded along the same lines. The aim here was to give things another appearance. The objects placed by Man Ray on sensitive photographic paper were often recognizable, though transformed and transported into a foreign world. It was precisely this relationship and this dialectic between the known and the unknown that helped to open up the mind to another reality.

In the eyes of the great majority of people, rayographs were the first photographic prints to attain an artistic value equivalent to that of painting. As Man Ray explained in his *Self Portrait*, he "was trying to do with photography what painters were doing, but with light and chemicals, instead of pigment, and without the optical help of the camera."[9] The rayograph showed that, contrary to received wisdom, the photograph was not simply a reproductive and documentary tool, but something creative and inventive, something that could give rise to imagery emerging from the artist's imagination, inspiration and thought.

9] *Man Ray*, Self Portrait, *New York*, 1963, *p.* 130.

The words occurring most frequently in articles of the day to describe Man Ray and his rayographs are "poet", "poetry" and "poetic", since these pictures are, technically speaking, the outcome of actual writing on photographic paper. An impression of movement was obtained by exposing the objects several times to different light sources. Man Ray wrote with a light bulb just as poets write with pens. White light replaced black ink. Man Ray became the supreme poet, writing with light.

Early in 1922, Tristan Tzara regarded Man Ray's rayographs as purest Dada works. The title of his album, *Champs délicieux* [Delicious fields], was signally inspired by the title of the piece by André Breton and Philippe Soupault, *Les Champs magnétiques* [Magnetic fields, 1920]. However, since this piece was regarded *a posteriori* by André Breton himself as the first Surrealist text, the rayographs are, by analogy, often considered to be the first Surrealist photographic works. The fact remains that the rayographs were not Surrealist works – Surrealism did not come into being until 1924. They are simply works showing a Dada spirit, based on the principle of the "destructive projection" of "all formal art", to borrow an expression used by Georges Ribemont-Dessaignes. Objects

are projected into an unknown world, and shown to us by way of a new art: rayography. The creation of this art was a means of ousting the classical arts, and its manner of expression made it possible to counteract the existing realist and abstract styles. In painting, specifically, abstract representation was not seen as an acceptable possibility for the Dadaists, because as long as the classical means of creation continued to exist, Dada would not. Using a new procedure, Man Ray managed to present a new vision of ordinary objects. Once set and arranged in relation to one another, their association helped to create a "plastic poetry": something novel and unknown yet distinctive, something visible and almost palpable, that emerged from Man Ray's writing with light and the photographic medium. The rayographs were not abstract, since they were the recording, through contact, of real objects. There was no room for the subconscious here, because the arrangement of the objects was carefully worked out. And it was no dream world that was represented, but a reality – a different reality, of course, but an actual one.

The parallel with Breton and Soupault's automatic writing in *Les champs magnétiques* thus referred solely to the technical process of the work. André Breton observed in 1921: "The automatic writing that appeared at the end of the 19th century was nothing less than thought photography."[10] It arose more from an idea than from a dream, or the subconscious or dark forces, as was explained later. The link between *Champs délicieux* and *Les Champs magnétiques* must therefore be considered in the light of the impact enjoyed by the piece written by André Breton and Philippe Soupault in 1920 – an impact that was felt at the height of the Dada period. Other techniques further established Man Ray's success and linked him with the Surrealist movement: double exposure and solarization. What is commonly known as double exposure is the overlaying of two negatives [in the enlarger or even at the moment of the shot]. This technique makes it possible to re-transcribe a movement or relief, and juxtapose two elements in such a way as to give them a specific sense, as may happen with a portrait [*Tristan Tzara*, 1921]. Man Ray used this technique extensively, but it was through solarization that he came to establish himself as one of the most important photographers in Paris.

10] *A. Breton,* Exposition Dada Max Ernst, *Paris, Au Sans Pareil,* 1921.

Solarization is technically defined as the partial reversal of values on a photograph, accompanied by a characteristic edging. This technique, obtained by switching on the light just when the development is taking place, was hitherto regarded as a laboratory accident. Man Ray mastered this process in 1929 and applied it to many portraits, nudes and fashion photographs. It was an immediate success, because it achieved a striking and most surprising effect for those days: a kind of materialization of the aura. This, where the occult sciences are concerned, can only be seen, in principle, by the initiated. Unlike the Surrealists, Man Ray had little interest in spiritualism, yet he was regarded as a Surrealist photographer partly because of this practice. What is more, it was not because of Surrealism that Man Ray developed his photographic art, but rather because of Man Ray that the Surrealist movement developed its photographic activity: While being part of the Dada movement, Man Ray was actually developing a poetic vision of objects, one of the favorite themes of Surrealism. Still in a Dadaist spirit, he broached the photographic medium like a creative art that was removed from reality, a tool offering complete freedom of production, whose documentary status itself became a source of playfulness [*Rrose Sélavy*, 1921]. With an instrument supposed to reproduce nature faithfully, he was photographing fantastical landscapes as early as 1920, e. g. "Here is the estate of Rrose Sélavy..."[11], later known as *Élevage de poussière* [Dust Breeding, ill. p. 117]. Finally, in 1920 Man Ray produced pictures displaying blatant eroticism and transformation. Rosalind Krauss[12] singles out the picture *Head, New York* as an important example of what Georges Bataille and, in his wake, the Surrealist photographers would later term *l'informe*, or shapelessness. However, it should be emphasized that the date of this picture was 1920, and that it took four more years for Surrealism to come into being.

Man Ray was unique in being the only photographer to make the shift from Dada to Surrealism, as well as the first photographer to work closely with the Surrealist movement, an isolated position he held for almost five years. The first Surrealist magazine, *La Révolution Surréaliste* published virtually only Man Ray pictures. The handful of other photographs used were for the most part pictures found in bric-à-brac

11] Élevage de poussière *[Dust Breeding] is a title given by Marcel Duchamp much later on. The photo appeared for the first time in October 1922 in issue no. 5 of* Littérature *under the title: "Voici le domaine de Rrose Sélavy / Comme il est aride – comme il est fertile – / comme il est joyeux – comme il est triste!" [Here is the estate of Rrose Sélavy / How arid it is – how fertile it is – / How joyous it is – How sad it is!"] and signed "Vue prise en aéroplane par Man Ray" ["View taken in an aeroplane by Man Ray"], which lent his technical work an acrobatic aspect, and fooled the reader for whom the geometric drawing appearing beneath the dust turned into the boundary lines of the fields of an 'estate' – Rrose Sélavy's estate.*

12] *In "Corpus delicti", in:* Le Photographique, Pour une Théorie des Ecarts, *Paris, Macula, 1990, p. 164-165.*

shops or even in popular and scientific magazines, and were therefore anonymous.

The desire to produce art "automatically" was predominant in Bretonian thinking. As an instant form of creation, photography became the ideal medium as far as painting was concerned, which called for a period of gestation, allowing reasoning to block direct access to the subconscious. But well ahead of the Surrealists, Man Ray had understood the creative power of photography. From the outset, its documentary essence and its apparent commitment to the real had given rise to an already acute awareness of the "unreality contained in reality itself".

The techniques applied by Man Ray in Paris enjoyed instant success. The use of photograms and solarization spread throughout France and then Europe like wildfire. The part played by French artists in this success story was akin to that of a gallery owners or publishers, which, incidentally, most of them were. Thanks to them, Man Ray had his works published in many magazines put out by the Dada and Surrealist movements [*Littérature, Mécano, Merz, La Révolution Surréaliste, Le Surréalisme au service de la Révolution, Minotaure*, etc.]. Even though his work was definitely brought about by a Dada spirit, Man Ray did not consider himself a 'Dadaist'. Thus, Man Ray cannot be pigeonholed in any specific category of artists, or in any particular movement. He remains unclassifiable.

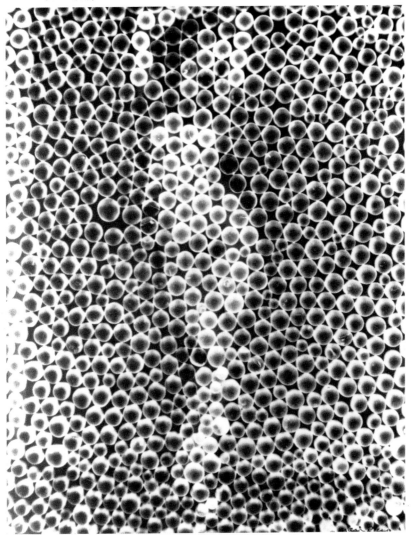

Untitled
1926

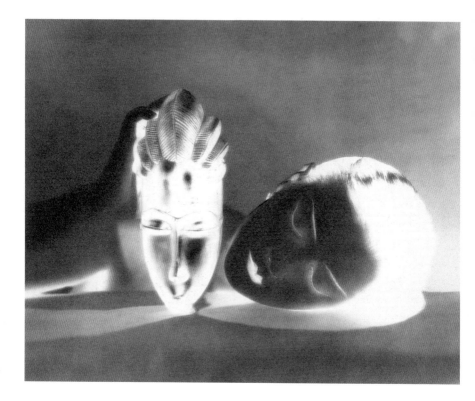

Noir et Blanche [reverse negative print]
1926

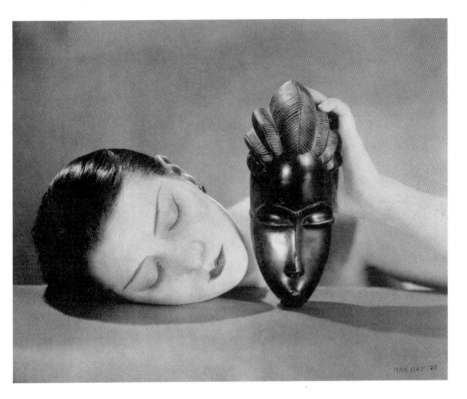

Noir et Blanche
1926

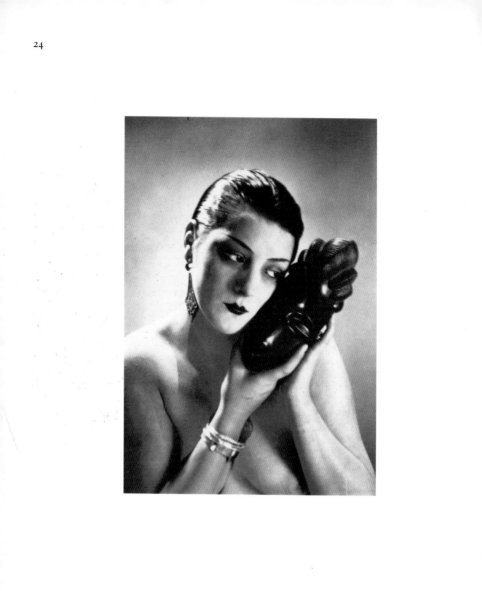

Noir et Blanche
1926

Untitled
c. 1925

Was die Wünsche betrifft, gibt es eigentlich keine so große Kluft zwischen dem Künstler und dem Betrachter. Allerdings kann sich der Künstler durch seine Mittel zu weit in technische Abenteuer hineinführen lassen und damit einen momentanen Bruch zwischen sich und dem Betrachter herbeiführen, der, von solchen *tours de force* zu stark beeindruckt, das ursprüngliche Thema aus dem Blick verlieren kann. Dennoch aber sind solche *tours de force* – ohne besondere Anstrengung durchgeführt – für den Künstler nichts weiter als eine Möglichkeit, sein Thema wirkungsvoller darzustellen.

As far as desires go, there is really not such a great gulf between the one who creates and the one who appreciates. Except, with the former his application may lead him too far into technical adventures, and thus create a momentary breach between himself and the spectator who, too impressed by tours de force, may lose sight of the original subject matter. And yet such tours de force when carried out without any special effort on the part of the artist, are merely means for making his subject matter more telling.

Vu sous l'angle du désir, l'abîme n'est vraiment pas si grand entre celui qui crée et celui qui juge. À ceci près que le premier, tout entier à sa tâche, risque de s'aventurer trop loin dans le recours à la technique, provoquant alors une scission temporaire entre lui et le spectateur, lequel pourra perdre de vue le sujet original à force d'être impressionné par des tours de force. Pourtant, s'ils sont accomplis sans effort particulier de la part de l'artiste, ces tours de force ne constituent que des moyens pour renforcer l'éloquence de son sujet.

Le violon d'Ingres
1924

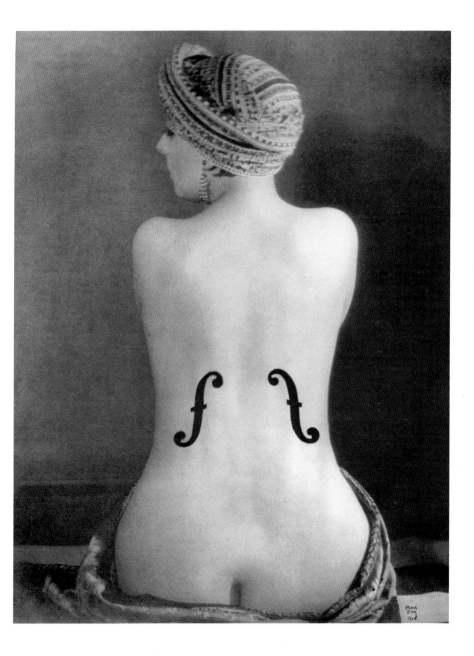

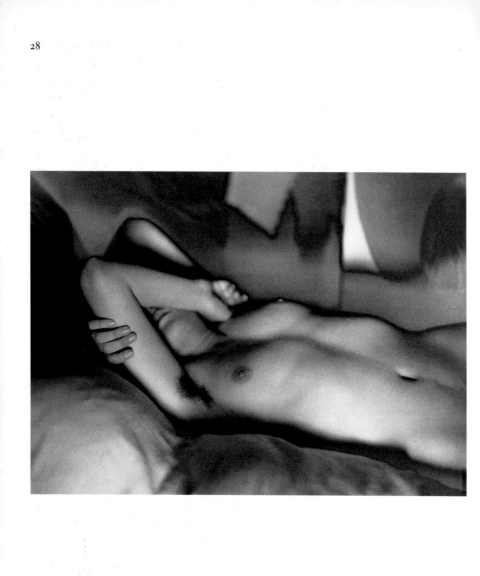

Meret Oppenheim
1933

Retour à la raison
1923

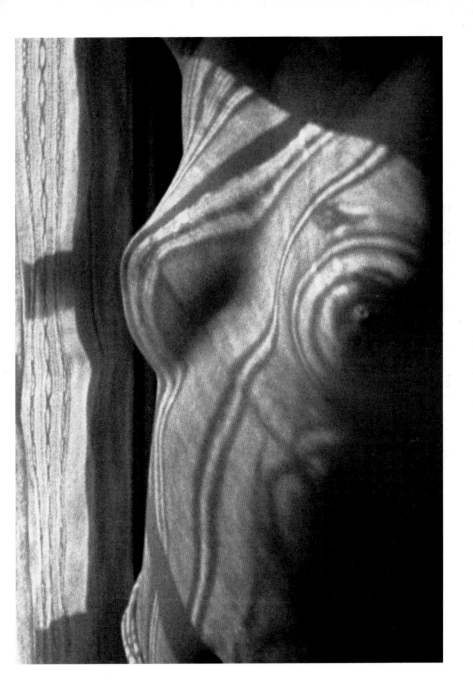

Zwei oder drei Lampen [um schneller arbeiten zu können], irgendeine Linse auf einem lichtundurchlässigen Kasten [seit der Erfindung der Kamera hat es keinen Fortschritt gegeben] und eine Flasche Entwickler sind alles, was man braucht, um ein restlos überzeugendes Bild zu realisieren.

Two or three lights [for greater speed in working], any lens on a light-tight box [no progress has been made in cameras since their invention], and a bottle of developer, are sufficient for the realization of the most convincing image.

Il suffit de deux ou trois sources d'éclairage [afin d'accélérer le travail], de n'importe quel objectif monté sur un boîtier hermétique [la fabrication du matériel n'a fait aucun progrès depuis l'invention de la photographie] et d'une bouteille de révélateur chimique pour réaliser une image de l'espèce la plus convaincante.

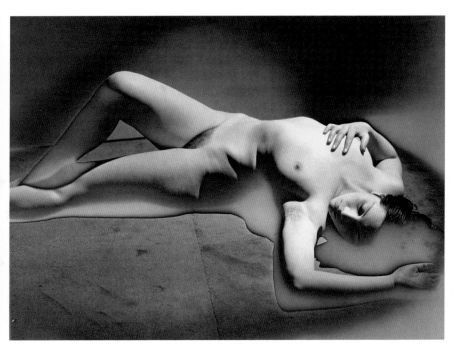

Primat de la matière sur la pensée
1932

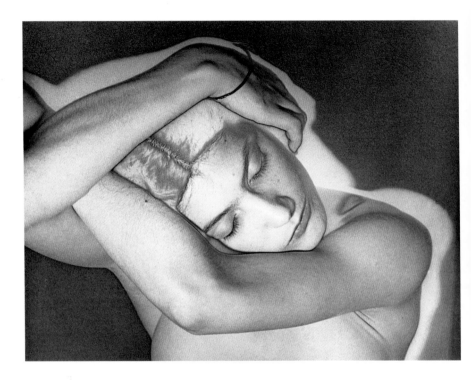

Untitled
1931

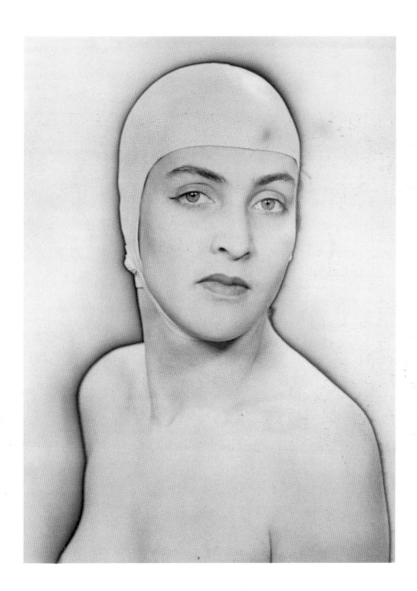

Meret Oppenheim
1932

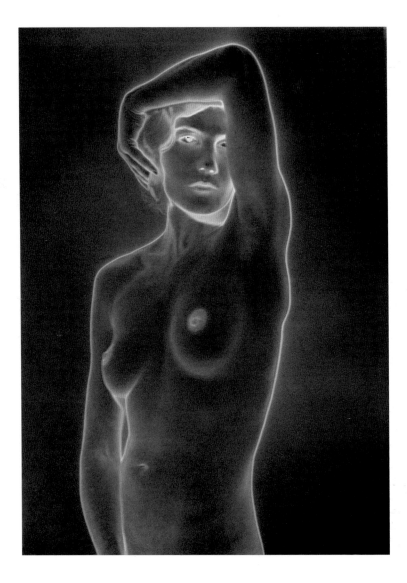

"Beauty in ultra violet" *[Published in* Harper's Bazaar, 1940*]*
c. 1931

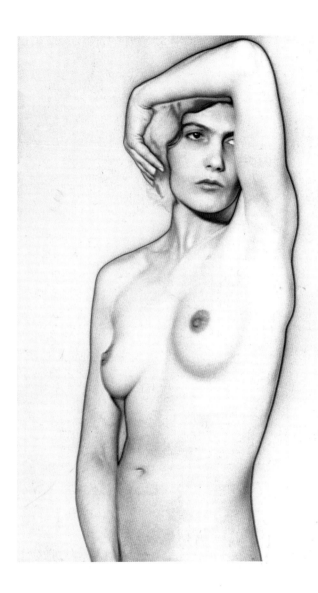

Untitled
c. 1931

Sehen Sie sich dieses Aktfoto an. Ein Freund hatte das Foto gesehen und sich in mein Modell verliebt. Er wollte ihr unbedingt vorgestellt werden. Ich sagte zu ihm: Komm her, sie ist bei mir. Und ich zeigte ihm [...] das »Mädchen«: Es war ein Gipsabguß der Venus von Milo [...]. Glauben Sie, daß der Fotoapparat das zu Wege gebracht hat?

Hey, look at this nude. A friend saw this photo, and he fell in love with my model. He wanted to be introduced to her, and wouldn't take no for an answer. I said to him: "Come round, she's at my place". And I showed him [...] "the girl": it was a plaster model of the Venus de Milo [...]. Do you think it's the camera that does that?

Tenez, regardez ce nu. Un ami avait vu cette photo, et il était tombé amoureux de mon modèle. Il voulait absolument lui être présenté. Je lui ai dit : viens, elle est chez moi. Et je lui ai montré [...] « la fille » : c'était un plâtre de la Vénus de Milo [...]. Vous croyez que c'est l'appareil qui a fait ça ?

Érotique voilée [Meret Oppenheim]
1933

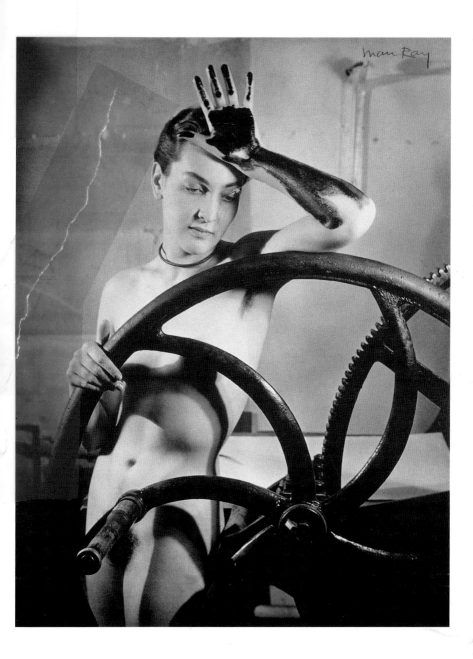

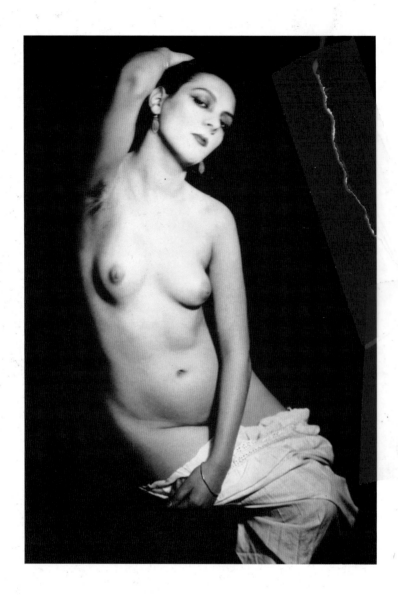

Kiki de Montparnasse
1922

Kiki de Montparnasse
1922

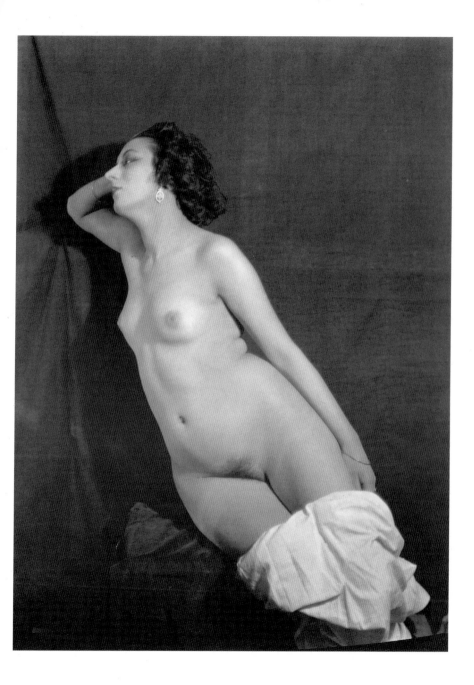

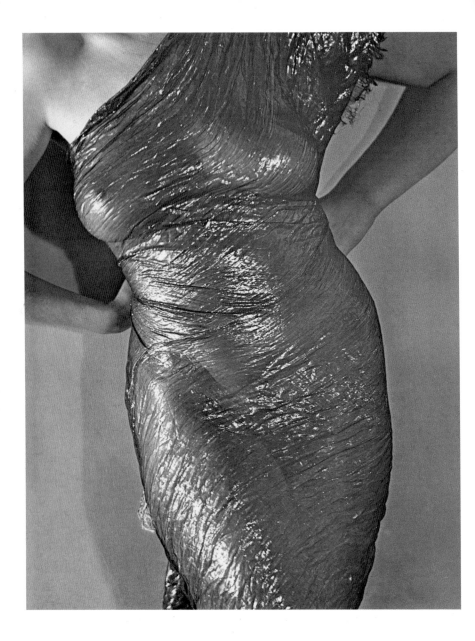

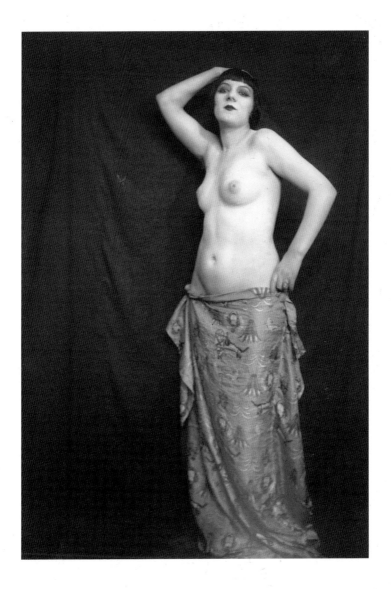

Anatomies

c. 1930

Kiki de Montparnasse

c. 1922

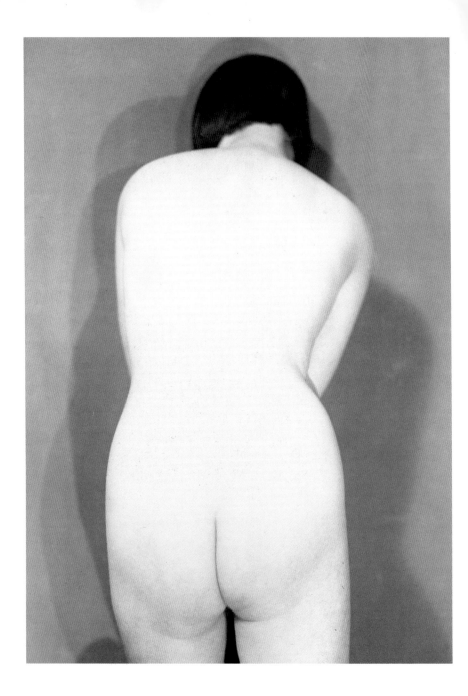

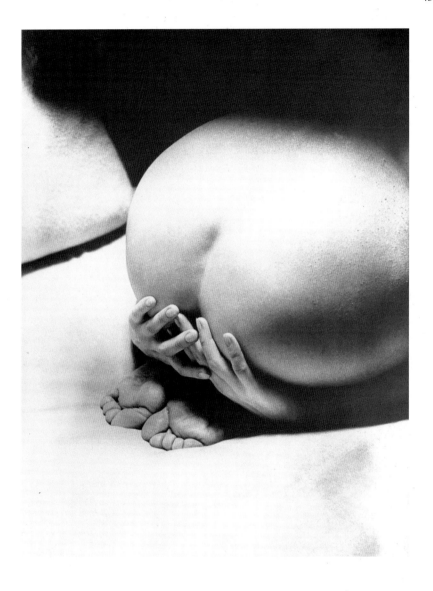

Untitled

1927

La Prière

c. 1930

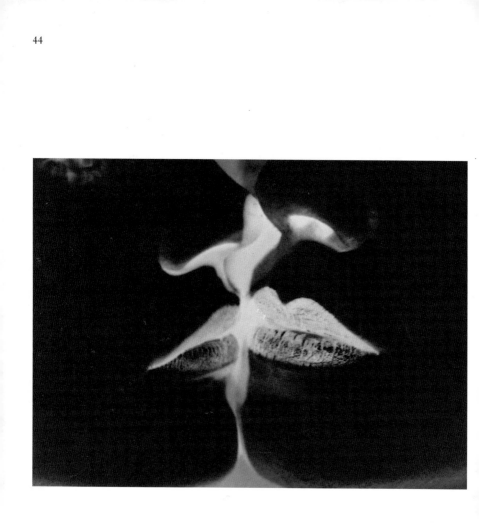

Le Baiser [negative print]
1935

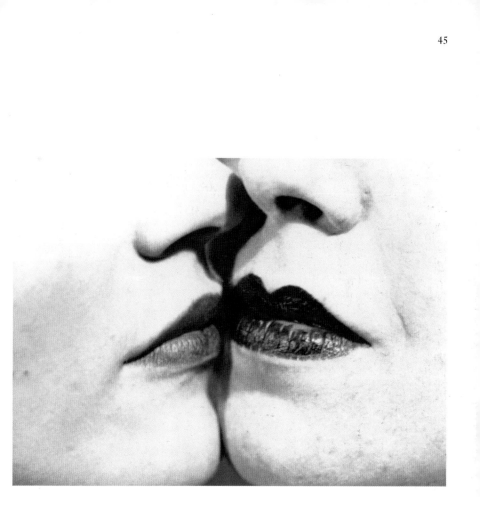

Le Baiser
1935

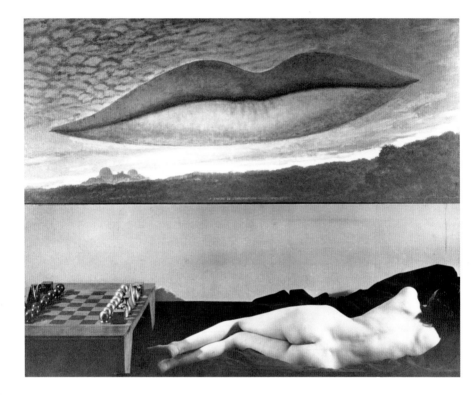

From the series «à l'heure de l'observatoire, les amoureux»
1934

Kein einziges Werk in diesem Œuvre kann als experimentell betrachtet werden. Die Kunst ist keine Wissenschaft.

Nor can any of this work be considered experimental. Art is not a science.

On ne peut tenir non plus aucune de ces œuvres pour expérimentales. L'art n'est pas une science.

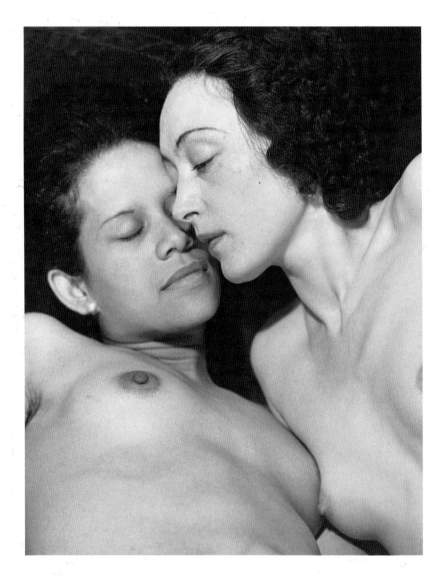

Ady and Nusch
1937

Ciné-sketch: Adam et Eve
[Marcel Duchamp, Bronia Perlmutter-Clair]
1924

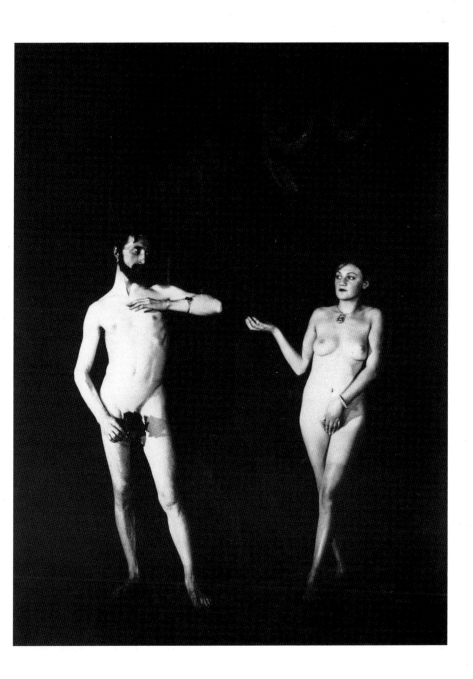

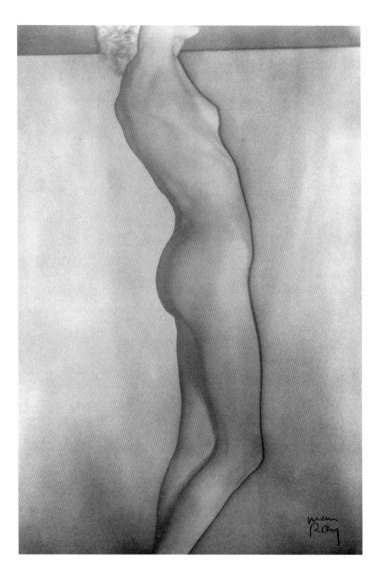

Untitled
1936

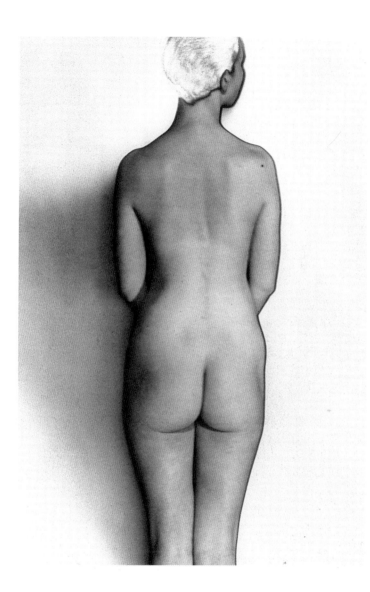

Untitled
c. 1931

Die Kunst variiert einfach in ihren Inspirationsquellen und ihren Entstehungsprozessen. Die Kunst ein und desselben Menschen kann unterschiedlicher Art sein, je nachdem, wie es um seine Neugier und seinen Sinn für Freiheit bestellt ist.

Art simply varies in its sources of inspiration and in its modes of execution. It can vary within one man, depending on his curiosity and on his sense of freedom.

L'art varie simplement dans ses sources d'inspiration et dans ses modes d'exécution. Il peut même varier chez tel ou tel individu, en fonction de sa curiosité et de son sentiment de liberté.

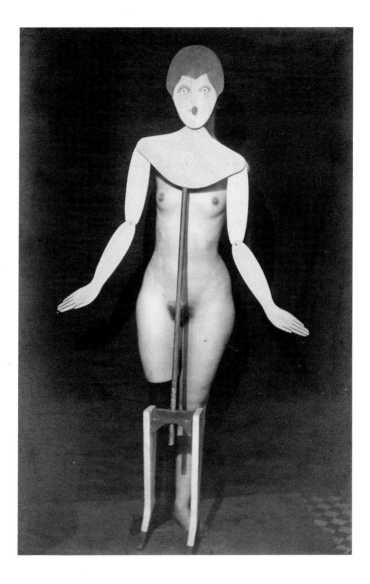

Coat Stand
1920

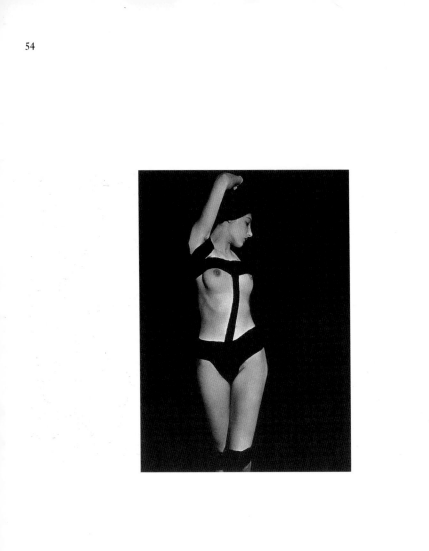

Blanc et Noir
c. 1929

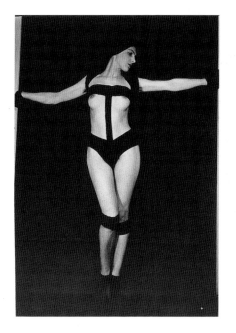 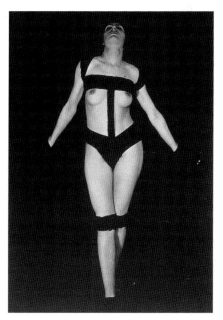

Blanc et Noir
c. 1929

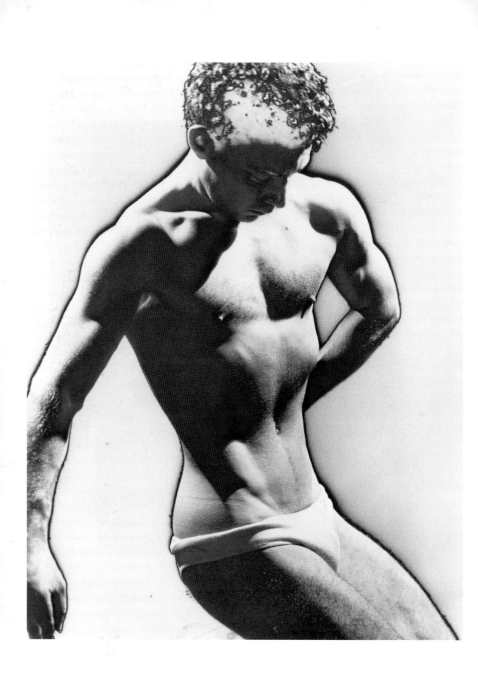

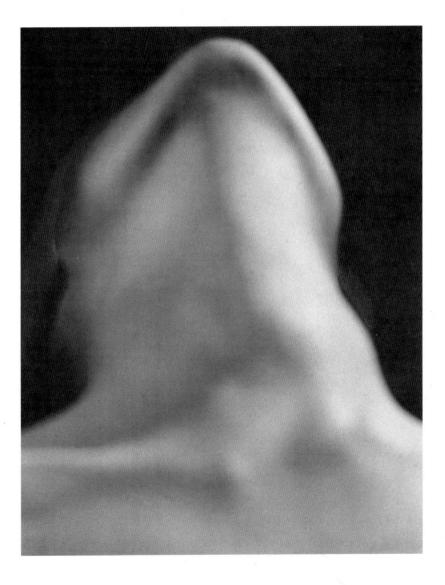

Untitled
1933

Anatomies
1929

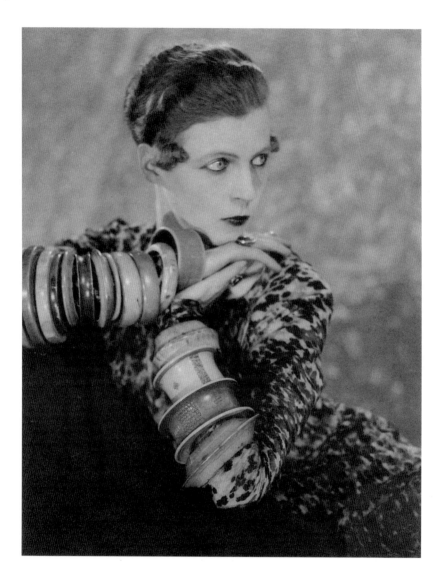

Nancy Cunard
1926

Träume haben keine Titel.

Dreams have no titles.

Les rêves n'ont pas de titre.

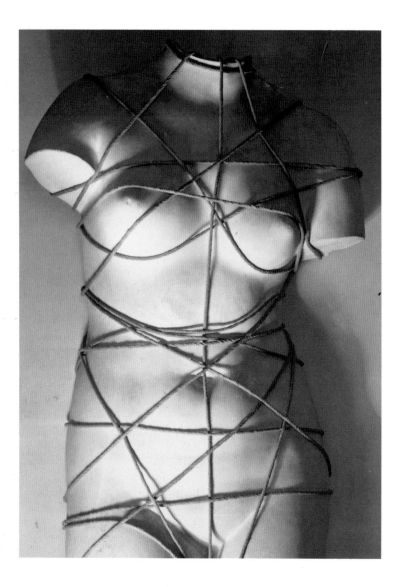

Vénus restaurée
1936

Untitled
c. 1936

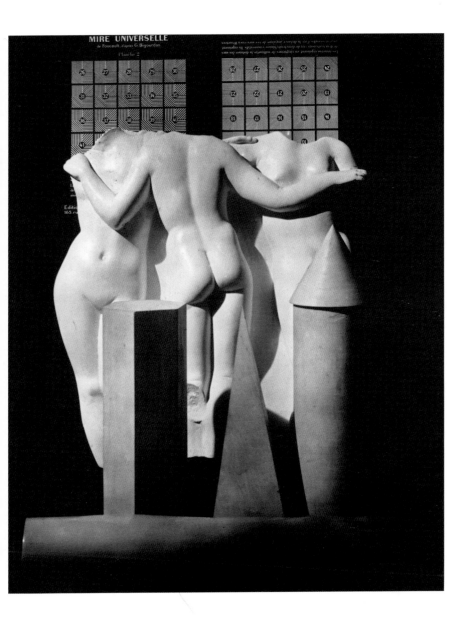

Untitled
1931

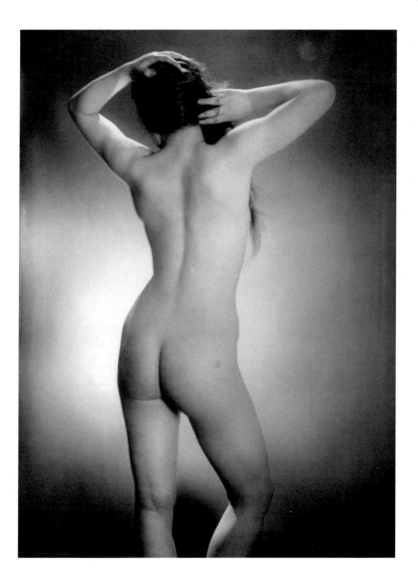

Chevelures
1937

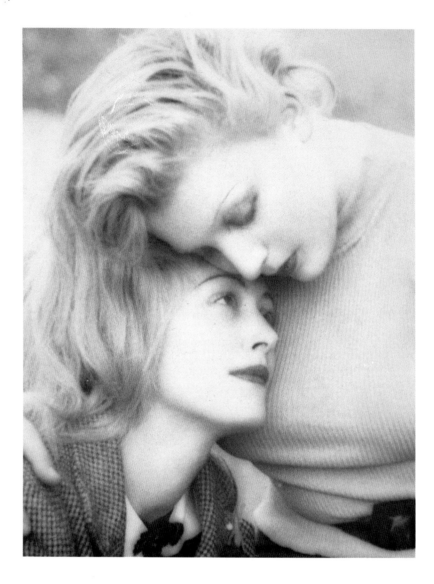

Nusch and Sonia
1935

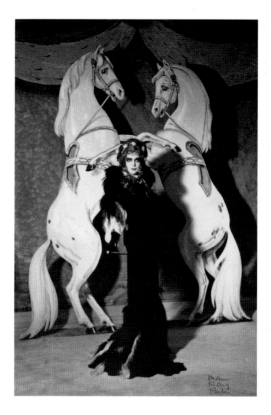

La Marquise Casati
1935

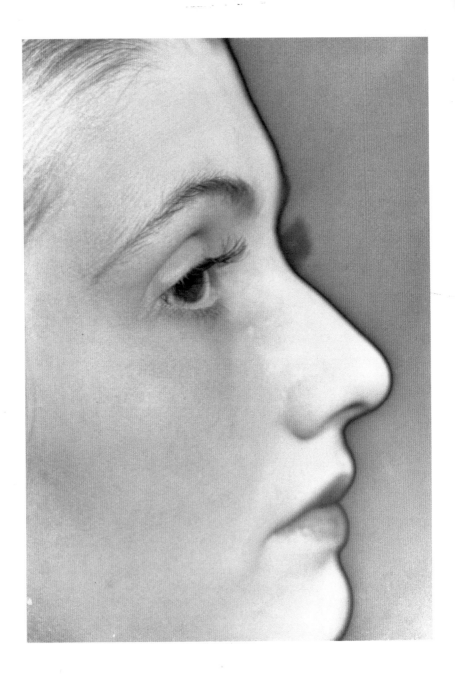

Kein einziges Werk in diesem Œuvre kann als experimentell betrachtet
werden. Die Kunst ist keine Wissenschaft.

Nor can any of this work be considered experimental. Art is not a science.

On ne peut tenir non plus aucune de ces œuvres pour expérimentales.
L'art n'est pas une science.

Untitled
c. 1930

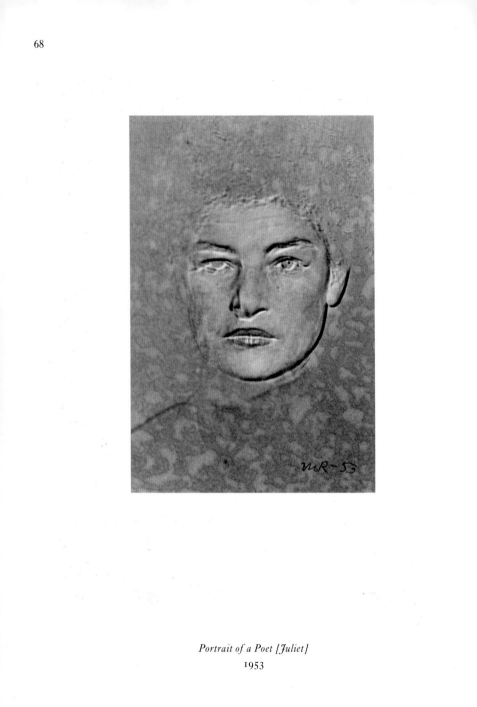

Portrait of a Poet [Juliet]
1953

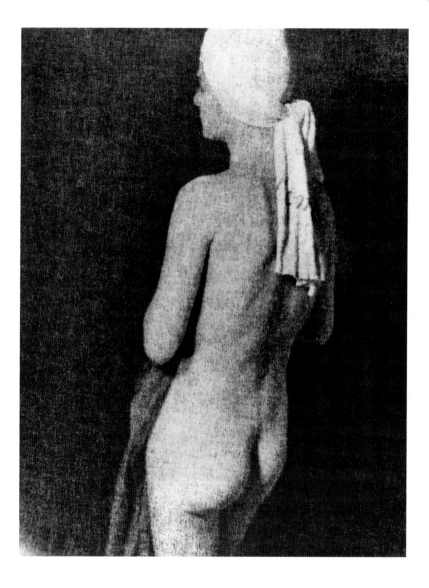

Juliet
c. 1945

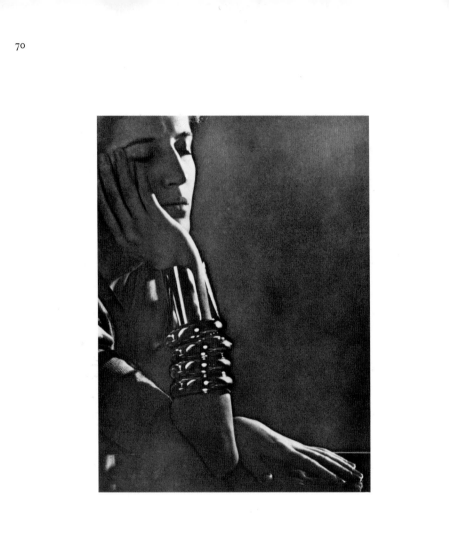

Jacqueline Goddard
c. 1932

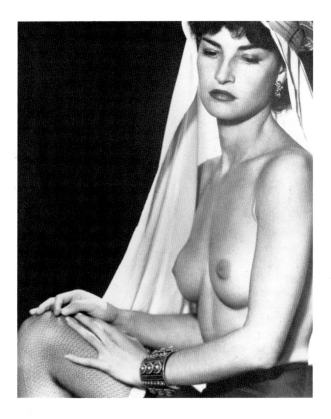

Juliet
c. 1946

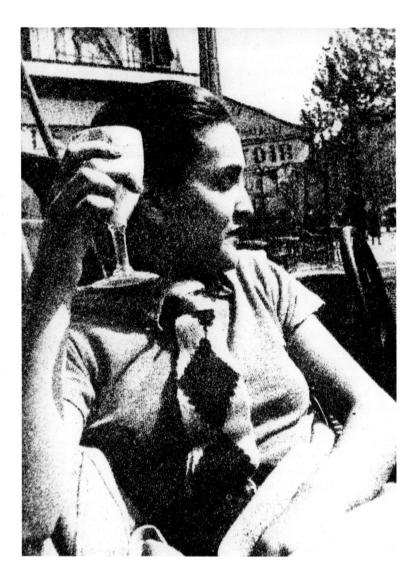

Meret Oppenheim
c. 1930

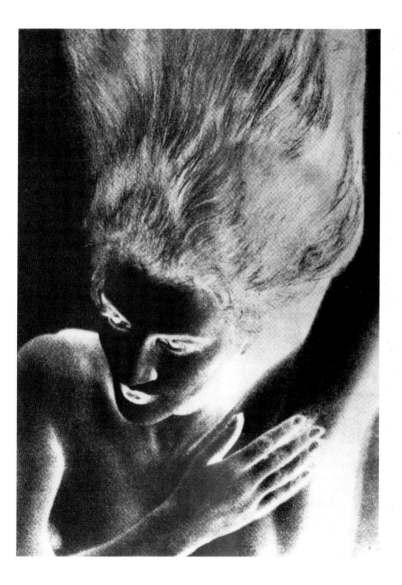

Jacqueline
1930

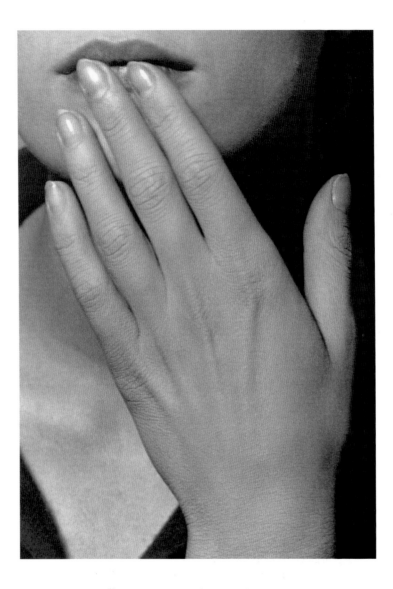

Untitled
1931

Über Man Ray

Auszug aus »Le Surréalisme et la Peinture«, Paris 1927
Übersetzung aus dem Französischen von Manon Maren-Grisebach[1]

Fast zur selben Zeit wie Max Ernst, aber in einer etwas anderen geisti-
gen Verfassung, auf den ersten Blick beinah entgegengesetzt, ging Man
Ray ebenfalls vom fotografischen Abbild aus; weit davon entfernt, ihm
ganz zu vertrauen, benutzte er es nur von Fall zu Fall, je nach seinen
eigenen Intentionen, je nach dem Gemeinsamen, das es uns in der Wie-
dergabe vermittelt. So nahm er ihm mit einem Schlage das Positive,
damit es die arrogante Haltung verlor, die sich die Fotografie anmaßte,
sich nämlich als das auszugeben, was sie gar nicht ist. Wenn tatsächlich
eben für Raimundus Lullus »der Spiegel ein durchsichtiger Körper ist,
der alle Erscheinungen, die ihm vorgehalten werden, in sich hineinneh-
men kann«, so läßt sich das vom fotografischen Abbild nicht behaupten,
das von den Erscheinungen von vornherein ein vorteilhaftes Aussehen
fordert und das dann nur das Äußerste und Flüchtigste an ihnen erfaßt.
Die gleichen Überlegungen träfen übrigens auf Filmaufnahmen zu, die
die Erscheinungen dem Film gemäß nicht nur im Leblosen, sondern
auch im Bewegungszustand entlarven sollen. An und für sich betrachtet
gehört die Fotografie, da sie mit einem ihr eigenen Gefühlswert ausge-
zeichnet ist, zu den besonders kostbaren Ersatzobjekten. Wann übrigens
wird man endlich aufhören, die vernünftigen Bücher mit Zeichnungen
zu illustrieren, statt einfach nur mit Fotografien? Die Fotografie ist,
obwohl sie eine besondere Suggestivkraft besitzt, doch bei genauerem
Hinsehen nicht das treue Abbild, das wir von dem bewahren möchten,
was nur allzubald verloren sein wird. So mußte, während die Malerei,
die von der Fotografie in der bloßen und einfachen Nachahmung der
wirklichen Dinge schon weit übertroffen war, sich die problematische
Frage ihrer Lebensberechtigung stellte und sie, wie man sah, beantwor-
tete, notwendig ein guter Techniker der Fotografie, der zugleich zu den
besten Malern zählte, sich damit befassen, einerseits der Fotografie ihre
Grenzen genau so weit abzustecken, wie sie eben ihren Anspruch aus-
dehnen darf, und andererseits sie für neue Zwecke zu nutzen, für die sie
nicht erfunden zu sein schien. Namentlich mußte er im Rahmen seiner

eigenen Möglichkeiten die Erforschung jenes Gebietes fortsetzen, das die Malerei glaubte für sich reservieren zu können. Es war Man Rays Glück, der geeignete Mann dafür zu sein. Ich halte es für Gerede, in seinem Werk zwischen dem, was fotografisches Porträt, was so unzutreffend abstrakte Fotografie genannt wird, und seinen eigentlichen malerischen Arbeiten zu unterscheiden. Diese drei Arten, die mit seinem Namen gezeichnet sind und die ein und derselben Entwicklungsstufe seines Geistes entsprechen, gehören eng zusammen, und ich weiß nur zu gut, daß er mit ihnen immer die gleiche Sichtbarkeit oder Unsichtbarkeit umkreist. Die besonders schönen und so eleganten Frauen, die Tag und Nacht ihre Haare den entsetzlichen Lampen im Atelier von Man Ray aussetzen, wissen sicher nichts davon, daß sie sich damit für eine Demonstration hergeben. Ich würde sie sehr in Erstaunen versetzen, wenn ich ihnen klarmachte, daß sie daran teilhätten, und zwar im selben Sinn wie eine Quarzlampe, ein Schlüsselbund, wie der Rauhreif oder wie das Farnkraut. Ein Perlenkollier gleitet von den nackten Schultern auf das weiße Blatt, auf dem es von einem Sonnenstrahl eingefangen wird und nun zwischen anderen Bildelementen dort liegt. Das, was nur Schmuck war, was nichts weiter war als Schmuck, wird. jetzt dem Spiel der Schatten anheimgegeben, den Schatten zum Gericht überantwortet. Es gibt nur noch Rosen in den unterirdischen Höhlen. Die übliche Behandlung, die sogleich diesem Blatte widerfahren wird, unterscheidet sich in nichts von der, die jenem anderen Blatte widerfährt, um auf ihm das Kostbarste der Welt in Erscheinung treten zu lassen. Die beiden Bilder leben und sterben durch die gleiche Erschütterung, zur gleichen Stunde, im gleichen sich verlierenden oder plötzlich verlöschenden Schein. Sie sind beinah immer gleich vollkommen, es fällt schwer zu denken, sie existierten nicht auf derselben Ebene, man meint, sie seien einander so unentbehrlich wie das Berührte und das Berührende. Ist dies Gold- oder Engelshaar? Wie kann man die Wachshand von der wirklichen unterscheiden?

Wer das Schiff der Fotografie sicher durch den nahezu unbegreifbaren Strudel der Bilder zu lenken versteht, der wird das Leben wieder in seine Fänge ziehen, so als ob man einen Film rückwärts drehen würde, so als ob es einer idealen Kamera gelingen würde, Napoleon vor sie hinzustellen, nachdem doch zuvor neu seine Spuren auf bestimmten Dingen entdeckt werden konnten.

1] *Die deutsche Übersetzung* Der Surrealismus und die Malerei *erschien* 1967 *im Propyläen Verlag, Berlin, S. 33–38. Die französische Originalfassung wurde veröffentlicht in:* La Révolution Surréaliste, *Nr. 9–10, 1. Oktober 1927, S. 41–42.*

Man Ray

EMMANUELLE
DE L'ECOTAIS

Der Erfinder der surrealistischen Fotografie

Man Rays Pariser Schaffensperiode [1921–1940] ist die interessanteste in seinem Gesamtwerk. In Paris entwickelt sich das Originäre seiner Kunst, dort erzielt er die größte Wirkung. Paris ist zu jener Zeit ein wichtiges künstlerisches Zentrum: Die Dada-Bewegung, 1916 in Zürich entstanden, hat in der französischen Hauptstadt Fuß gefaßt, vor allem durch die Ankunft von Tristan Tzara. Man Ray, dessen Kunst in Amerika keine Anerkennung fand, sieht in Paris das gelobte Land. Sein engster Freund in den Vereinigten Staaten ist ein Franzose: Marcel Duchamp. Dieser nimmt ihn in seinen Kreis auf und stellt ihn all jenen vor, die von entscheidender Bedeutung für die Entwicklung seiner Arbeit und seiner Karriere werden sollten.

Der erste Mensch, der eine wichtige Rolle im Werk Man Rays spielen sollte, war also Marcel Duchamp, und zwar noch vor seiner Übersiedlung nach Paris. Ihre erste Begegnung fand 1915 in Ridgefield, New Jersey, statt. Vom ersten Augenblick an haben sie sich gut verstanden, obwohl die Sprache als Hindernis zwischen ihnen stand. Marcel Duchamp, dessen ganzes Streben darauf gerichtet war, »eine Malerei äußerster Präzision und eine Schönheit der Indifferenz« zu erreichen, was ihn schließlich dazu brachte, ganz mit dem Malen aufzuhören, fand in Man Ray und dessen wachsendem Interesse für die Fotografie sowohl einen Freund als auch einen wichtigen Mitarbeiter. Man Ray seinerseits strebte die Weiterentwicklung seiner Malerei in Richtung einer flächenbetonten Zweidimensionalität an, die wahrscheinlich in seiner Entdeckung der Fotografie begründet lag. Bei seinen ab 1917 entstandenen Aerografien, seinen Airbrush-Bildern, ging er nach demselben Prinzip vor wie Duchamp, indem sie sich beide ganz von den klassischen Maltechniken abwandten. In seiner neuen Leidenschaft für die Fotografie fand Man Ray in Marcel Duchamp einen überzeugten Fürsprecher. Besser gesagt, beide Künstler entdeckten in der Fotografie das ideale

schöpferische Mittel, das ihre Suche nach »optischer Präzision« befriedigte und bei Duchamp zu einer differenzierten Beschäftigung mit optischen Gegebenheiten [*Rotierende Glasscheiben*, 1920] führte, aber auch zu einigen Teilen für das *Große Glas* [1915–1923] wie *Die Luftpumpen* [1914], von denen wir wissen, daß die fotografische Realisierung ihm von Man Ray nahegelegt worden war.

Nehmen wir zum Beispiel die Kreation von *Rrose Sélavy*: Bestimmt ist Duchamp die Idee zu dieser Hochstapelei in den Sinn gekommen, weil er einen Fotografen in seiner Nähe hatte. Was kann es Besseres geben als eine Fotografie, um einem Sachverhalt, einem Ereignis oder in diesem Fall einer Person Realität zu verleihen, sie zu verbürgen, ihr einen Authentizitätsnachweis auszustellen? Und umgekehrt, kann man nicht in Man Rays Beschäftigung mit dem Schatten [*Integration of Shadows*, 1919, Abb. S. 9] und den Maschinen [*La femme*, 1920, Abb. S. 8] einen Einfluß von Marcel Duchamps Arbeiten über die geworfenen Schatten und die Mechanik des *Großen Glases* sehen?

Und in einem weiteren Punkt haben sich Marcel Duchamp und Man Ray getroffen: Für einen Künstler ist es das wichtigste, eine Idee auszudrücken, die verwendete Technik stellt dabei keinen Selbstzweck dar, sondern ist Mittel, das gesetzte Ziel zu erreichen:»Mein Ziel war es, mich dem Inneren zuzuwenden und weniger dem Äußeren«, sagte Marcel Duchamp. Und er fuhr fort:»Unter diesem Blickwinkel kam ich zu dem Schluß, daß ein Künstler egal was benutzen konnte [...], um das auszudrücken, was er sagen wollte«.[1] Jedenfalls haben sich beide »vom physischen Akt der Malerei entfernt«.[2] Marcel Duchamp erklärte dazu, er wolle »zu einer absolut *trockenen* Zeichnung zurückkehren, zur Komposition einer *trockenen* Kunst«, wofür die »mechanische Zeichnung [...] das beste Beispiel«[3] sei. Und genau das machte Man Ray mit den Aerografien, mit den Clichés-verre und der Fotografie.

Dieses vollkommene Einverständnis führte dazu, daß Man Ray seinem Freund nach Paris folgte. Das schmähliche Scheitern der Zeitschrift *New York Dada*, die die beiden in New York ins Leben gerufen hatten, war für den Amerikaner eine eindeutige Bestätigung: Einzig die französische Hauptstadt war »reif«, seinen zutiefst von Dada geprägten Geist anzunehmen.

1] *Marcel Duchamp, Gespräch mit James Johnson Sweeney, wiedergegeben von Michel Sanouillet in:* Duchamp du signe, *nouvelle édition, Paris [Flammarion],* 1975, *S.* 171.

2] *Marcel Duchamp,* op.cit., *S.* 171.

3] *Marcel Duchamp,* op.cit., *S.* 179.

Es war am Abend des 22. Juli 1921 in Paris, als Man Ray durch Marcel Duchamps Vermittlung die ganze Dada-Gruppe traf: André Breton, Jacques Rigaut, Louis Aragon, Paul Éluard und seine Frau Gala, Théodore Fraenkel und Philippe Soupault. Das erstaunlichste für Man Ray war, daß keiner von ihnen Maler war. Sie waren alle Dichter oder Schriftsteller. Tatsächlich läßt sich keinerlei Einfluß seitens dieser Künstler auf Man Rays Werk feststellen. André Breton jedoch, der die Zeitschrift *Littérature* leitete, erkannte sofort, wie Man Ray ihm nützlich sein könnte. Als Fotograf nämlich wurde er dem Herausgeber schnell unentbehrlich; Breton nahm regelmäßig Kontakt zu ihm auf und schickte ihn zu den Künstlern, um die Arbeiten fotografieren zu lassen, die er in seiner Zeitschrift veröffentlichen wollte. Man Ray profitierte von dieser Aufgabe in zweifacher Hinsicht: Einerseits nutzte er jeden Fototermin, um ein Porträt des betreffenden Künstlers aufzunehmen, andererseits verlangte er als Gegenleistung von André Breton, der ihn nicht bezahlte, seine Fotoarbeiten in der Zeitschrift zu reproduzieren. Seine Erfahrung und der Erfolg auf dem Gebiet der Porträtfotografie [er hatte im März 1921 auf der *Fifteenth Annual Exhibition of Photographs* in Philadelphia einen Preis für das Porträt von Berenice Abbott bekommen] und die Mundpropaganda funktionierten so gut, daß Man Ray innerhalb kürzester Zeit mit sämtlichen Pariser Berühmtheiten jener Epoche zusammentraf und sie alle ihm weitere Kunden zuführten: Gertrude Stein machte ihn mit Pablo Picasso und Georges Braque bekannt; Jean Cocteau führte ihm die ganze Geldaristokratie zu, die auf der Suche nach einem originellen Porträtfotografen war. Nach und nach wurde Man Rays Atelier sogar zur Pilgerstätte für Ausländer, die sich in Paris aufhielten. Da die Porträts der Damen aus der Pariser Gesellschaft in den 20er Jahren häufig als Modefotografien dienten, kam Man Ray auch in Kontakt mit dem Couturier Paul Poiret, und ab 1924 begann er regelmäßig für die Zeitschrift *Vogue* zu arbeiten. Sein Erfolg wurde dadurch noch größer, daß er parallel zu diesen Auftragsarbeiten seine persönlicheren Arbeiten in den Zeitschriften *Littérature, Les Feuilles Libres, The Little Review* und sogar in *Vanity Fair* veröffentlichte.

Der Auslöser für diesen Erfolg war zweifellos seine Erfindung der Rayografie gegen Ende des Jahres 1921 oder Anfang 1922. In der

Folge entwickelte sich Man Ray zum Meister der fotografischen Manipulation, vor allem durch die Doppelbelichtung und die Solarisation, zwei Techniken, die die künstlerische Fotografie aufwerteten und die bis dahin in Paris vorherrschende reine Fotografie in den Schatten treten ließen. Im Gegensatz zu anderen Fotografen seiner Zeit, die den modernen Menschen mit Hilfe einer modernen Technik in den Mittelpunkt stellen wollten, ohne mit der Technik »Schindluder zu treiben«, benutzte Man Ray die Fotografie wie jedes andere Medium auch. Er veränderte die Einstellung während der Belichtung, retuschierte und bearbeitete das Negativ[4], arbeitete mit Umkehrentwicklung und seitenverkehrten Bildern; er fotografierte sogar ohne Fotoapparat, kurz gesagt, Man Ray erfand die surrealistische Fotografie.

Was üblicherweise »Fotogramm« oder »Rayografie« genannt wird, ist ein einfaches Verfahren, das darin besteht, Gegenstände direkt auf lichtempfindliches Papier zu legen und sie einige Sekunden lang dem Licht auszusetzen. Entwickelt man das Papier anschließend auf normale Weise, erhält man ein Bild, dessen Hell-Dunkel-Werte vertauscht sind. Man Ray berichtete, daß er dieses Verfahren entdeckt habe, während er in seiner Dunkelkammer Modefotos für Paul Poiret entwickelte. Seine Erklärungen klingen zwar amüsant, sind aber nicht überzeugend. Bei Man Ray ist ganz offensichtlich, daß er seine schöpferischen Prozesse geheimhalten wollte, was seiner Grundüberzeugung entspricht, wonach das Entscheidende nicht die verwendete Technik ist, sondern das Werk, das am Ende herauskommt. Man Ray sagte sogar, daß »eine gewisse Verachtung für das physikalische Mittel zum Ausdruck einer Idee unabdingbar ist, um diese auf bestmögliche Weise umzusetzen«.[5] Die Anekdote, in der er seine Erfindung dem Zufall zuschreibt, ist also nicht sehr stichhaltig. Hingegen wissen wir, daß Tristan Tzara, der damals eng mit Man Ray befreundet war, eine Sammlung von Schadografien besaß, die Christian Schad [1894–1982] 1918/19 angefertigt hatte. Schad gehörte zur Gruppe der Dadaisten in Zürich und hatte sich durch die frühen Arbeiten von Henry Fox Talbot[6] anregen lassen. Für seine Schadografien benutzte er direkt schwärzendes Papier: »ein wenig empfindliches Material, das man bei Sicht, in gedämpftem Licht, präparieren konnte, um es anschließend dem Sonnenlicht auszusetzen. Der

4] Siehe hierzu La photographie à l'envers, Centre Georges Pompidou [Le Seuil], Paris, 1998.

5] Man Ray, »L'Âge de la Lumière«, in: inotaure, 1933, Nr. 3–4, S. 1.

6] William Henry Fox Talbot [1800–1877] stellte 1834/35 Abdrücke von Gegenständen auf lichtempfindlichem Silberchloridpapier her, die er »fotogenische Zeichnungen« nannte.

Vorteil dieses Verfahrens bestand darin, daß man keine Dunkelkammer brauchte.«[7] Man Ray hingegen fertigte seine Rayografien in der Dunkelkammer an:»Erst nachdem der Abzug entwickelt und fixiert war, konnte er bei Tageslicht betrachtet werden. Der Hauptgrund für diese Vorgehensweise lag wahrscheinlich darin, daß so die Möglichkeit bestand, die Intensität oder den Einfall des Lichts bewußt zu modifizieren.«[8] Hinzu kommt, daß Christian Schad auf das lichtempfindliche Papier ausschließlich Scherenschnitte und flache Gegenstände legte und so Bilder erzeugte, die kubistischen Collagen ähnelten. Man Ray hingegen verwendete alle Arten von dreidimensionalen Gegenständen und vor allem Glasobjekte, deren Schatten oder Lichtdurchlässigkeit es ermöglichten, unterschiedliche Helligkeitswerte auf den schwarzen und weißen Flächen zu erzielen. Die Kenntnis der Arbeiten von Christian Schad in der Sammlung eines nahen Freundes von Man Ray läßt also darauf schließen, daß dieser die neue Technik nicht durch Zufall »entdeckt« hat, wie er selbst behauptete, sondern daß diese Schadografien ihn dazu angeregt haben, eine neue Ausdrucksform für sich zu kreieren.

Man Rays Experimente im Fotolabor sind vergleichbar mit seinen Arbeiten aus früheren Zeiten: In seinen Bildern aus der New Yorker Zeit hatte er sein Anliegen zum Ausdruck gebracht, auf »lichtempfindliche« Weise, also mit dem Mittel der Fotografie, das Eigenleben der Gegenstände vorzuführen, ihre Unabhängigkeit, ihre Fähigkeit, etwas anderes zu bedeuten als das, wofür sie gemacht worden waren: *La femme* [1920, Abb. S. 8] ist ein Quirl oder Schneebesen, dessen Bedeutung durch die Indirektheit und Vieldeutigkeit der Titel transformiert wird. Es existieren andere Versionen mit dem Titel *Man* [1918] oder *L'Homme.* Die Rayografie geht nach demselben Prinzip vor. Es handelt sich darum, den Dingen eine andere Erscheinungsform zu geben. Die Gegenstände, die Man Ray auf das lichtempfindliche Papier gelegt hat, sind häufig erkennbar, jedoch völlig transformiert und dadurch in eine fremde Welt transponiert. Durch diese neue Beziehung, diese Dialektik zwischen Bekanntem und Unbekanntem, wird es möglich, den Geist für eine neue Realität zu öffnen.

Die Rayografien waren die ersten fotografischen Arbeiten, die, obgleich in wesentlich höherer Anzahl entstanden, den gleichen Rang

7] *Floris M. Neusüss and Renate Heyne, in:* László Moholy-Nagy, compositions lumineuses, 1922–1943, *Centre Georges Pompidou, Paris,* 1995, *S.* 14–15.

8] Op. cit.

9] *Man Ray,* Selbstporträt. Eine illustrierte Autobiographie, *München* 1983, S. 126.

einnahmen wie seine Malerei. Wie Man Ray in seinem *Self Portrait* schreibt, versuchte er, »mit der Photographie etwas ähnliches wie die Maler, aber nicht mit Farbe, sondern mit Licht und Chemikalien und ohne die optische Hilfe der Kamera«.[9] Die Rayografie stellte unter Beweis, daß die Fotografie, entgegen der herrschenden Vorstellung, nicht nur reproduzierend und dokumentarisch war, sondern ebenfalls kreativ und innovativ, und daß sie Bilder hervorbringen konnte, die der Phantasie, der Inspiration und der Gedankenarbeit des Künstlers entsprungen waren.

Die Begriffe, die man in Artikeln aus jener Zeit über Man Ray und seine Rayografien am häufigsten findet, sind »Poet«, »Poesie« und »poetisch«. Technisch gesehen sind diese Bilder tatsächlich das Ergebnis einer Schrift auf lichtempfindlichem Papier. Der Eindruck von Bewegung entsteht dadurch, daß die Gegenstände mehrfach unterschiedlichen Lichtquellen ausgesetzt worden sind. Man Ray schreibt mit einer Glühbirne, wie der Dichter mit einem Stift schreibt. Das weiße Licht ist an die Stelle der schwarzen Tinte getreten. Man Ray wird zum Inbegriff eines Dichters, der mit Licht schreibt.

Zu Beginn des Jahres 1922 wurden Man Rays Rayografien von Tristan Tzara als vollkommene Dada-Schöpfungen angesehen. Der Titel seines Albums *Champs délicieux* [Köstliche Felder] mit zwölf Rayografien lehnt sich deutlich an den Titel eines Textes von André Breton und Philippe Soupault an, *Les Champs magnétiques* [Die magnetischen Felder] aus dem Jahre 1920. Dieser wurde im nachhinein von André Breton selbst als der erste surrealistische Text bezeichnet, und entsprechend werden die Rayografien häufig als die ersten surrealistischen Fotografien angesehen. Doch die Rayografien sind keine surrealistischen Werke – der Surrealismus entstand erst im Jahr 1924 –, sondern Arbeiten aus dem Geist von Dada, die auf dem Prinzip der »destruktiven Projektion aller formalen Kunst« basierten, um eine Formulierung von Georges Ribemont-Dessaignes zu benutzen. Die Gegenstände werden in ein unbekanntes Universum projiziert und uns über den Umweg einer neuen Kunst, der Rayografie, vorgeführt. Durch die Erfindung dieser neuen Kunst wird es möglich, die klassische Kunst zu verdrängen, und die neue Form macht es möglich, bis dahin existierende

abstrakte oder realistische Darstellungsformen zu verdrängen. Vor allem in der Malerei wurde die abstrakte Darstellung von den Dadaisten nicht als akzeptable Möglichkeit angesehen; zwar bestanden die klassischen künstlerischen Ausdrucksmittel auch weiterhin, Dada aber gehörte nicht dazu. Man Ray gelang es, mittels eines neuen Verfahrens Gegenständen, vor allem Gebrauchsgegenständen, eine neue Sichtweise zu verleihen. Sie waren sorgfältig angeordnet, so daß sie zueinander in Beziehung treten konnten, und durch diese neue Zuordnung entstand eine »plastische Poesie«. Nicht nur ein Traumbild, wie man es später unter dem Einfluß des Surrealismus zu nennen pflegte, sondern das Bild einer anderen, neuen Realität, einer unbekannten, aber dennoch wahrnehmbaren, einer sichtbaren und fast greifbaren, dank der Lichtschrift, dank des fotografischen Mediums. Die Rayografien sind nicht abstrakt, denn sie sind durch Kontakt mit realen Gegenständen entstandene Aufnahmen. Das Unbewußte hat hier nichts zu suchen, denn die Anordnung der Gegenstände ist genau überlegt. Hier wird keine Traumwelt dargestellt, sondern eine Realität, zwar eine andere, aber eine vorhandene.

Die Parallele zum automatistischen Schreiben von Breton und Soupault in *Les Champs magnétiques* bezieht sich also einzig auf das technische Verfahren des Werkes. André Breton schrieb 1921:»Das automatistische Schreiben, das gegen Ende des 19. Jahrhunderts aufkam, ist im Grunde eine Fotografie des Denkens.«[10] Hierbei geht es also um die Idee und nicht um den Traum, das Unbewußte oder dunkle Kräfte, wie es im nachhinein interpretiert worden ist. Die Beziehung zwischen den *Champs délicieux* und *Les Champs magnétiques* muß zweifellos darin gesehen werden, welchen Einfluß der Text von André Breton und Philippe Soupault 1920 ausübte, ein Einfluß, der in der Hochzeit von Dada wirksam war.

Es gab noch andere Techniken, die Man Rays Erfolg ausmachten und ihn mit der surrealistischen Bewegung verbanden: die Doppelbelichtung und die Solarisation. Doppelbelichtung ist das Übereinanderlegen zweier Negative [im Vergrößerer oder bei der Aufnahme selbst]. Diese Technik ermöglicht die Übertragung einer Bewegung, eines Reliefs, oder das Nebeneinander zweier Elemente in der Weise,

10] *André Breton,* Exposition Dada Max Ernst, *Paris [Au Sans Pareil]* 1921.

11] *Den Titel* Élevage de poussière *(Staubzucht) hat Marcel Duchamp dem Foto später gegeben. Die Arbeit war zum ersten Mal im Oktober 1922 in der Nr. 5 der Zeitschrift* Littérature *erschienen, unter dem Titel:* »Dies ist das Reich von Rrose Sélavy / Wie ist es trocken – wie ist es fruchtbar – / Wie ist es fröhlich – wie ist es traurig!« *und mit der Unterschrift* »Aufnahme aus dem Flugzeug von Man Ray«, *womit er dem technischen Aspekt seiner Arbeit etwas Akrobatisches verlieh und den Betrachter irreführte, für den die geometrische Zeichnung, die unter dem Staub aufscheint, zu Grenzlinien eines Feldes auf einem Gutshof wurde, zu einer* »Domäne«, *der von Rrose Sélavy.*

12] *In* »Corpus delicti«, in: Le Photographique, Pour une Théorie des Ecarts, *Paris [Macula] 1990, S. 164–165.*

daß ihnen eine spezielle Bedeutung verliehen wird, wie dies bei einem Porträt der Fall sein kann [*Tristan Tzara*, 1921]. Man Ray benutzte diese Technik häufig, aber in erster Linie war es die Solarisation, durch die er sich in Paris einen Namen als bedeutender Fotograf machte.

Die Solarisation ist technisch gesehen eine teilweise Umkehrung der Hell-Dunkel-Werte auf einer Fotografie, dazu gehört auch die charakteristische Umrandung. Sie entsteht, wenn im Augenblick der Entwicklung eine Lichtquelle eingeschaltet wird; diese Technik wurde bis dahin als Laborunfall angesehen. Man Ray wandte dieses Verfahren seit 1929 an und stellte eine Vielzahl von Porträts, Aktaufnahmen und Modefotografien in dieser Technik her. Er hatte damit sofort Erfolg, denn er erzielte mit dieser Neuerung faszinierende Effekte, die für jene Zeit so erstaunlich waren: eine Art Materialisierung der Aura. Diese ist nach den okkulten Wissenschaften im Prinzip nur Eingeweihten sichtbar. Im Gegensatz zu den Surrealisten war Man Ray kein Anhänger des Spiritismus, gleichwohl wurde er, teils wegen dieser Praxis, als surrealistischer Fotograf angesehen. Im übrigen ist es nicht dem Surrealismus zu verdanken, daß Man Ray seine Fotokunst entwickelte, wie häufig behauptet wird, sondern vielmehr war es Man Ray, durch den sich der Surrealismus in der Fotografie entwickelte: Schon als er sich der Dada-Bewegung verschrieb, verlieh Man Ray den Gegenständen eine poetische Sicht, und dies wurde zu einem der Lieblingsthemen des Surrealismus. Als Dadaist betrachtete er das Medium Fotografie als eine kreative Kunst, die von der Realität abgelöst ist, ein Werkzeug, das alle Freiheit der Ausführung für ihn bereithielt und dessen dokumentarische Funktion ihm Anlaß zum Spielen gab [*Rrose Sélavy*, 1921]. Mit einem Instrument, das eigentlich dazu gedacht war, die Natur getreu abzubilden, fotografierte er ab 1920 fantasmagorische Landschaften [»Dies ist die Domäne von Rrose Sélavy…«[11], auch *Élevage de poussière* (Staubzucht, Abb. S. 117), genannt]. Ab 1920 schuf Man Ray Bilder, bei denen die Erotik und die Transformation offensichtlich waren. Rosalind Krauss[12] hebt die Bedeutung des Bildes *Head, New York* für eine künstlerische Richtung hervor, die später von Georges Bataille und nach ihm von den surrealistischen Fotografen »Informel« genannt wurde. Es muß aber mit Nachdruck darauf hingewiesen werden, daß das Entstehungs-

datum dieses Bildes im Jahre 1920 liegt und der Surrealismus sich erst vier Jahre später formierte.

Man Ray war einerseits der einzige Fotograf, der von Dada zum Surrealismus übergegangen ist, andererseits war er der erste Fotograf, der der surrealistischen Bewegung nahestand, er war sogar der einzige, der dieser Position fast fünf Jahre lang treu blieb. Die erste surrealistische Zeitschrift, *La Révolution Surréaliste*, veröffentlichte praktisch ausschließlich Bilder von Man Ray. Die wenigen anderen reproduzierten Fotos sind meist Fundstücke aus Trödelläden, oder sie stammten aus Illustrierten und wissenschaftlichen Zeitschriften, waren also anonym. Die Idee der »automatistischen« Realisierung der Kunst beherrschte das Denken André Bretons und seiner Anhänger. Die Fotografie als Form der Augenblickskreation wurde zum idealen Medium im Gegensatz zur Malerei, die eine Entstehungszeit erfordert, zumal der direkte Zugang zum Unbewußten durch das Nachdenken in Fesseln gelegt wird. Man Ray aber hatte schon lange vor den Surrealisten das kreative Potential der Fotografie erkannt. Ihr dokumentarisches Wesen, ihre eindeutige Anbindung an die Realität hatten ihm schon früh bewußt gemacht, daß die »Irrealität in der Realität selbst enthalten ist«.

Die Techniken, die Man Ray in Paris entwickelte, verzeichneten unmittelbare Erfolge. Das Fotogramm und die Solarisation fanden zuerst in Paris und dann in ganz Europa schnelle Verbreitung. Dabei spielten französische Künstler etwa die Rolle eines Galeristen oder eines Verlegers – was sie übrigens meistens auch waren. Ihnen hatte es Man Ray zu verdanken, daß er seine Arbeiten in vielen Zeitschriften der dadaistischen und surrealistischen Bewegung veröffentlichen konnte [*Littérature, Mécano, Merz, La Révolution Surréaliste, Le Surréalisme au service de la Révolution, Minotaure* etc.]. Obwohl sein Werk ganz sicher aus dem Geist von Dada entstanden ist, betrachtete Man Ray sich nicht als Dadaisten. Insofern gehört er nicht in eine spezielle Kategorie von Künstlern, noch ist er einer Bewegung zuzuordnen. Man Ray ist nicht klassifizierbar.

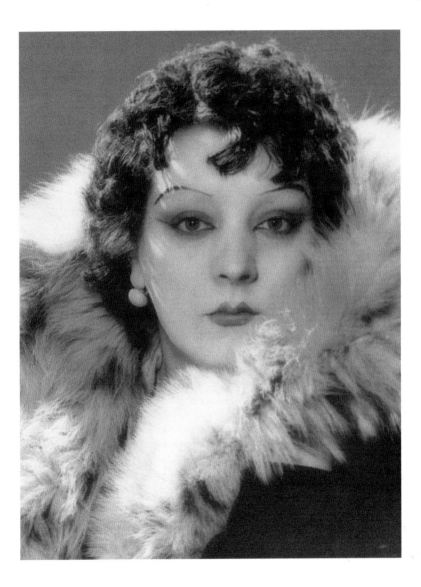

Kiki de Montparnasse
c. 1929

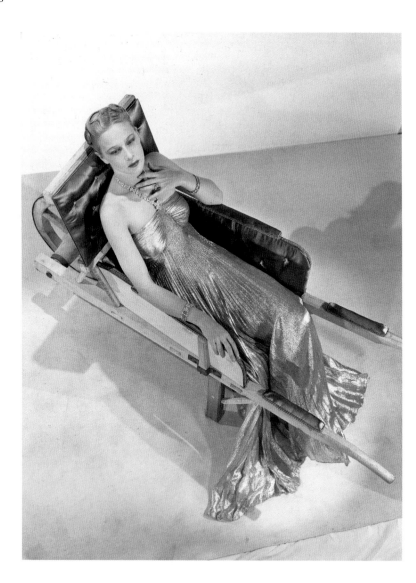

Fashion
1937

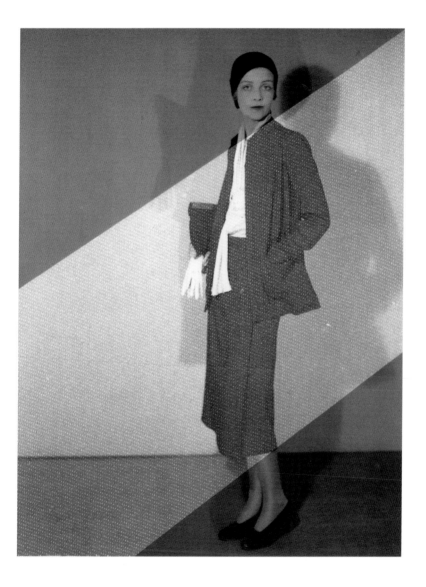

Fashion
c. 1935

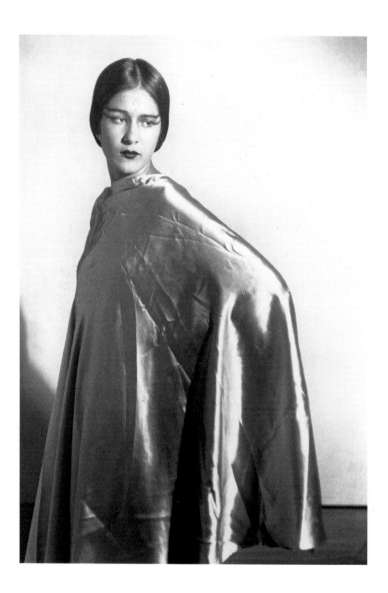

Untitled
c. 1930

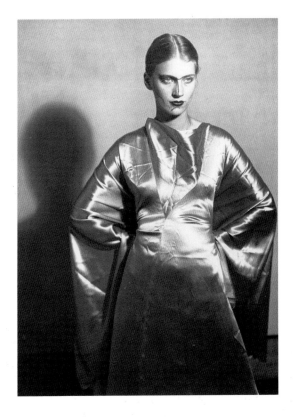

Lee Miller
c. 1930

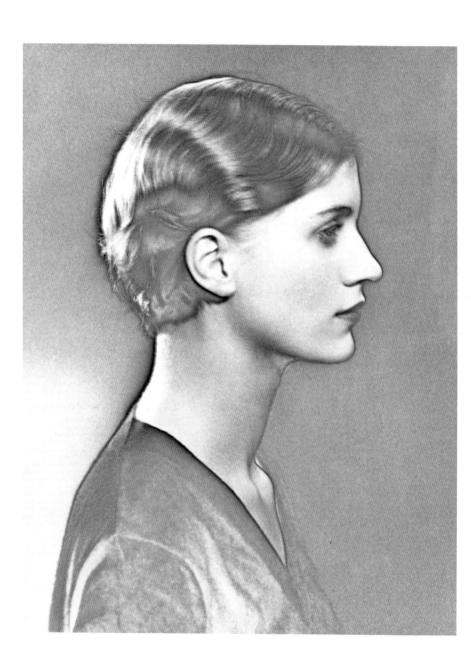

Es gab immer und gibt immer zwei Beweggründe für alles, was ich tue:
die Freiheit und die Freude.

There have always been, and there still are, two themes in everything I do:
freedom and pleasure.

Il y a toujours eu, et il y a toujours deux motifs dans tout ce que je fais :
la liberté et le plaisir.

Lee Miller
1929

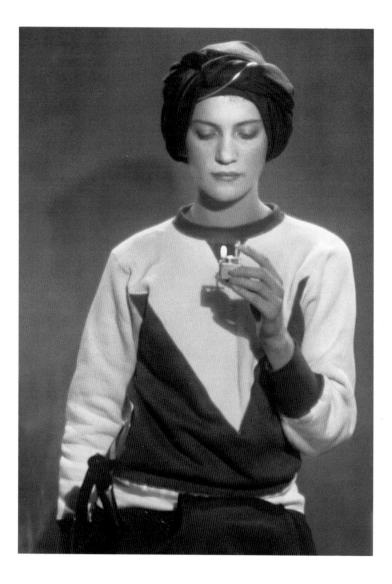

Lee Miller
1930

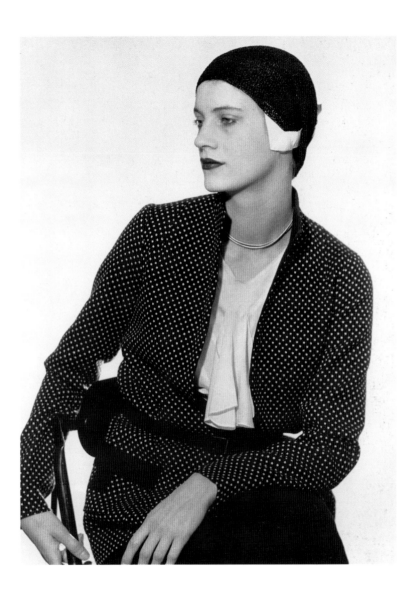

Lee Miller
1930

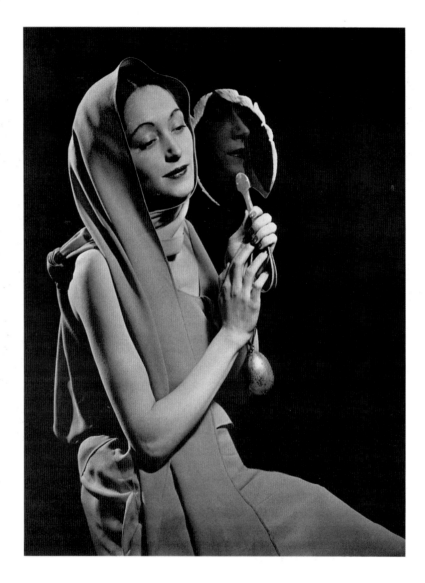

Nusch au miroir
1935

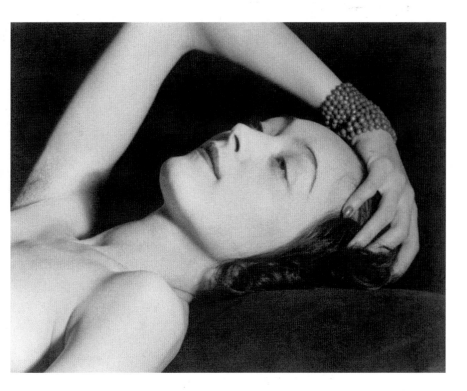

Nusch
1935

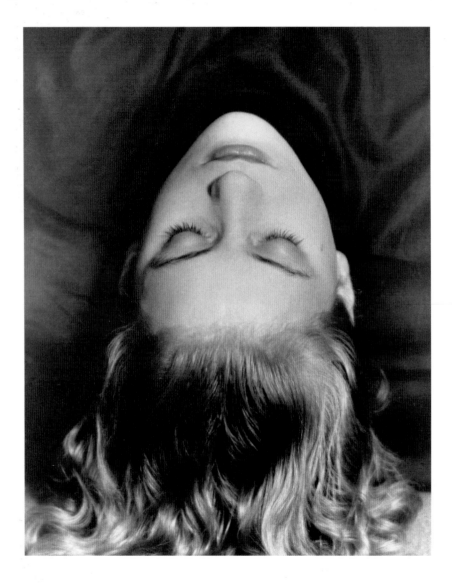

Lee Miller

c. 1930

Meret Oppenheim

1933

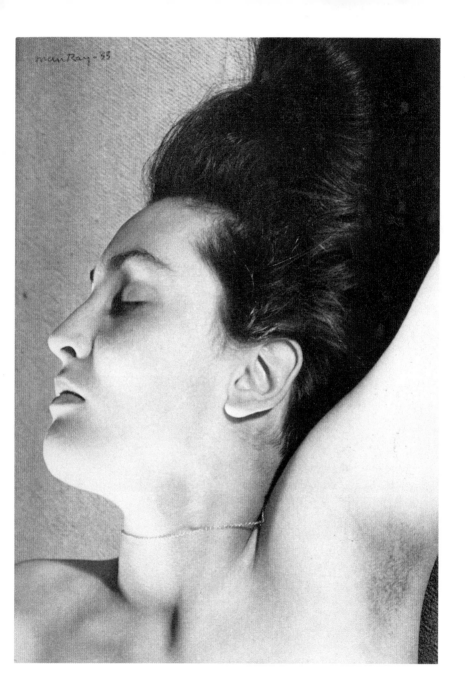

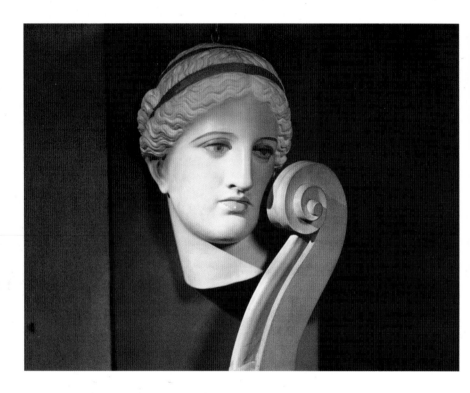

Untitled
c. 1930

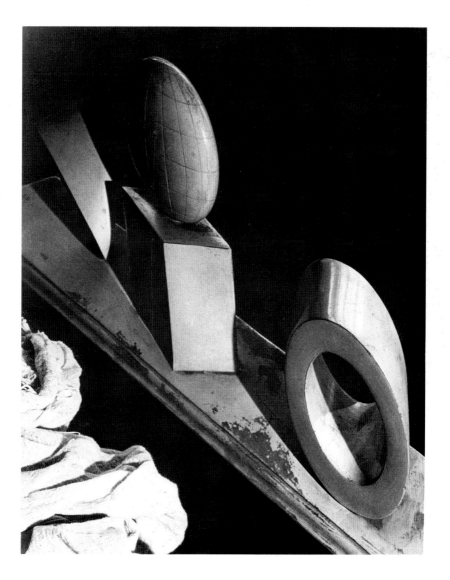

Perspective d'un cube, d'une sphère, d'un cône et d'un cylindre
1934–1936

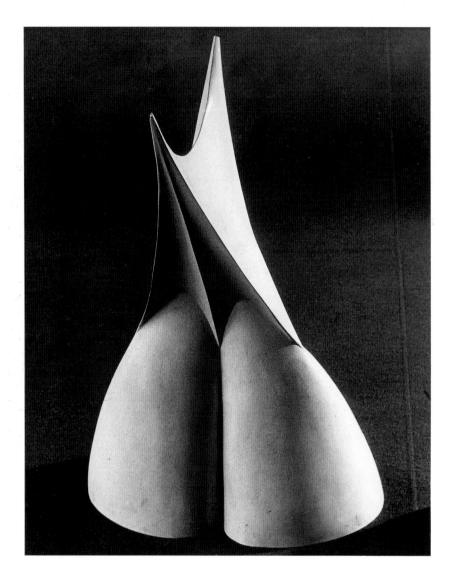

Objet mathématique
1934–36

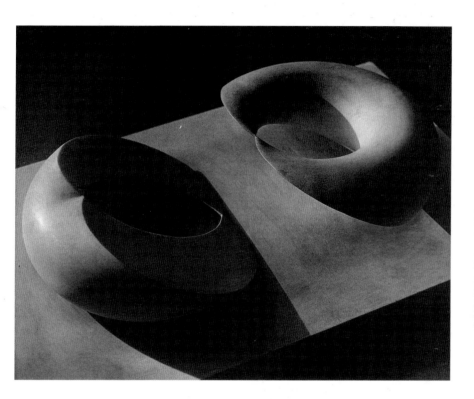

Objet mathématique
1934–36

Wenn ich Fotos machte, wenn ich in der Dunkelkammer war, ließ ich absicht-
lich alle Regeln außer acht, mischte die unpassendsten Mittel zusammen,
verwendete Filme, deren Haltbarkeitsdatum überschritten war, machte die
schlimmsten Sachen gegen alle Chemie und gegen das Foto, aber das sieht
man nicht.

*When I took photos, when I was in the darkroom, I deliberately dodged all the rules, I mixed
the most insane products together, I used film way past its use-by date, I committed heinous
crimes against chemistry and photography, and you can't see any of it.*

Quand je prenais des photos, quand j'étais dans la chambre noire, j'évitais
exprès toutes les règles, je mélangeais les produits les plus insensés, j'utilisais
des pellicules périmées, je faisais les pires choses contre la chimie et la photo,
et ça ne se voit pas.

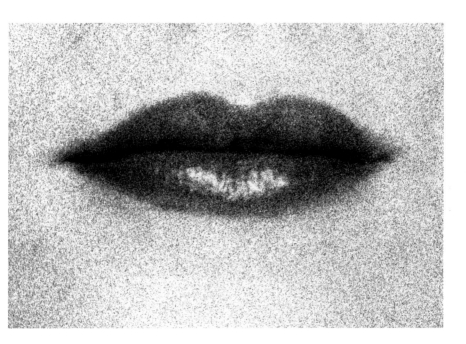

Untitled
c. 1930

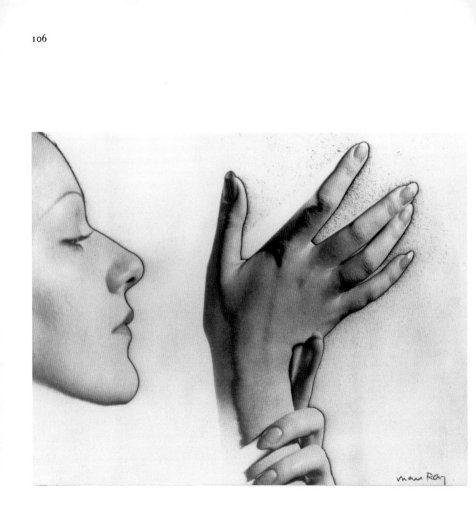

Untitled
1932

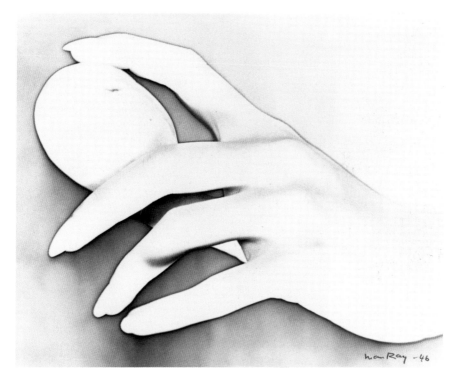

Untitled
1946

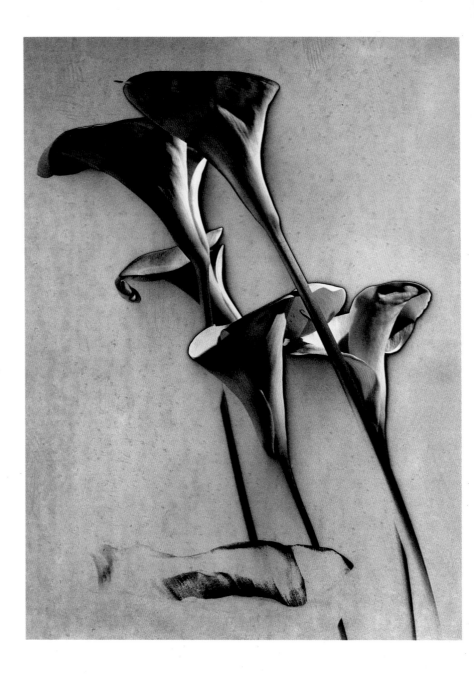

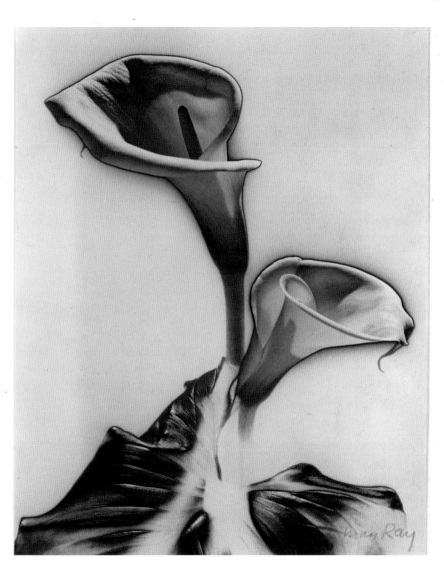

Les Arums
1930

Calla Lilies
1930

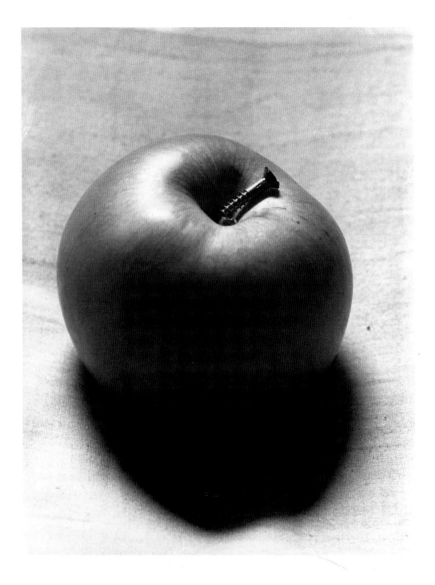

Untitled
1931

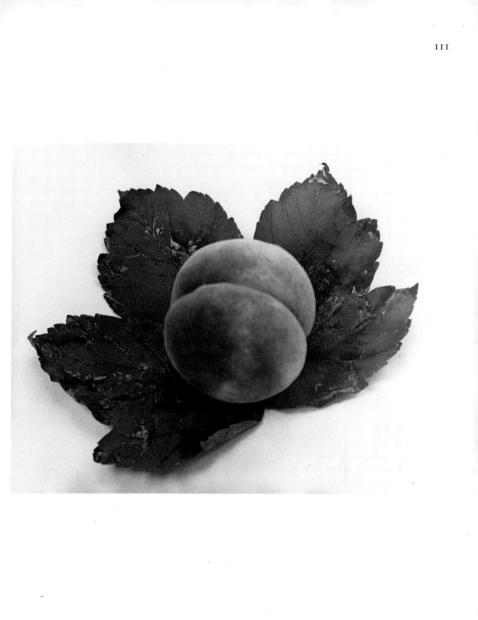

Untitled
1931

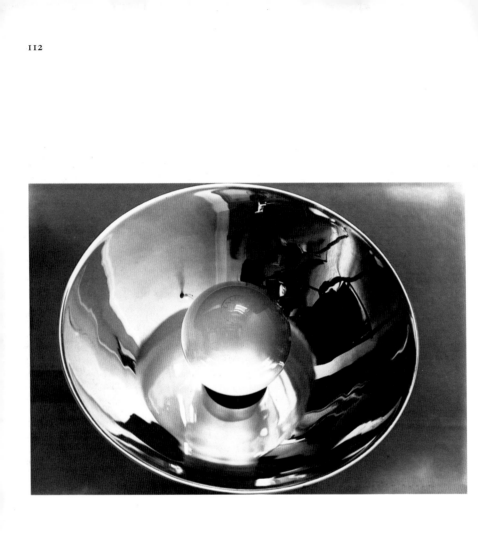

Untitled
1932

Untitled
1932

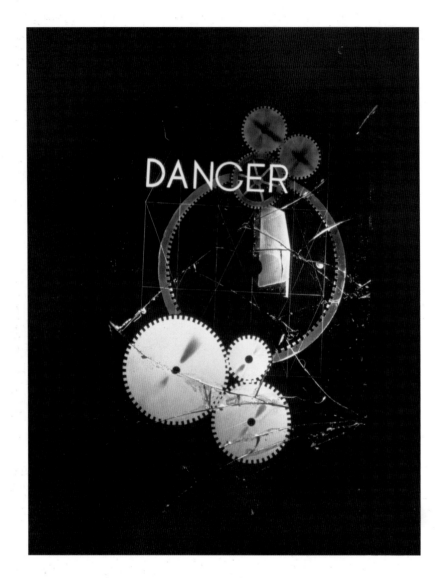

Dancer/Danger
1920

Untitled
c. 1935

Viele Menschen möchten wissen, wie ich bestimmte Effekte erziele. Es genügt, wenn ich dazu sage, daß ich diese Effekte als ganz persönliche Formen betrachte, die durch die Verletzung gemeinhin akzeptierter Prinzipien im Arbeitsprozeß – aber unter strenger Beachtung bekannter Naturphänomene – erreicht werden. Ich will nicht, daß diese Formen sich allgemein verbreiten; dadurch würde nur der Technik wieder einmal zu Lasten des eigentlichen Themas zu große Aufmerksamkeit zuteil.

For those who wish to know how I obtain certain effects, it is sufficient to say that I regard these as very personal forms, obtained by the violation of accepted principles in the process of working, but obeying well known phenomena in nature, forms that I have no desire of seeing universally adopted, which would again give to technique too great an interest, and distract the attention from the value of the subject itself.

À ceux qui voudraient savoir comment je réalise certains effets, je me contenterai de répondre que ces effets sont pour moi des formes très individuelles, auxquelles je parviens en transgressant les principes admis dans le processus de travail, mais non sans respecter des phénomènes bien connus de la nature : ce sont des formes dont je ne souhaite en aucun cas qu'elles soient universellement adoptées car là encore, ce serait accorder trop d'intérêt à la technique et détourner l'attention de la valeur du sujet lui-même.

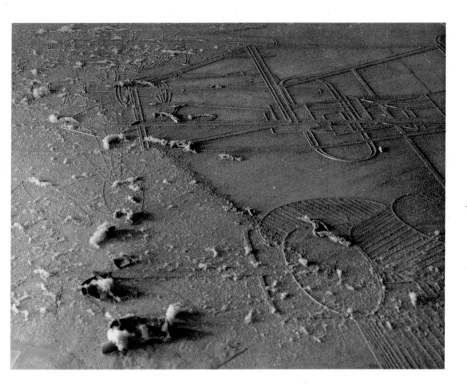

Élevage de poussière
1920

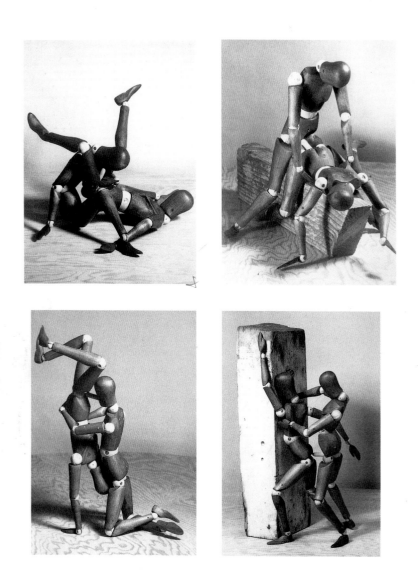

Mr. and Mrs. Woodman
1947

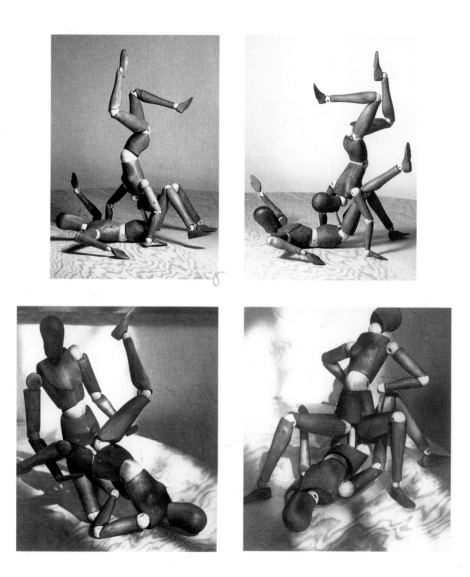

Mr. and Mrs. Woodman
1947

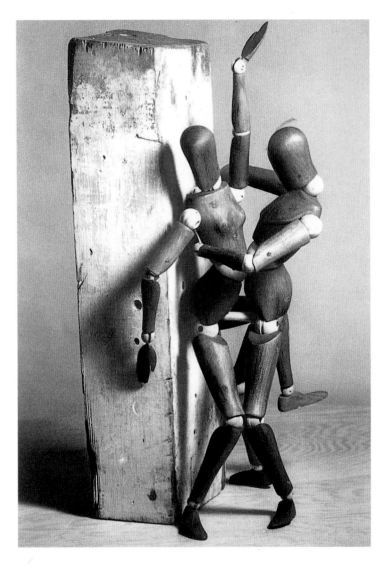

Mr. and Mrs. Woodman
1947

À propos de Man Ray ANDRÉ BRETON

Extrait de « Le Surréalisme et la Peinture », Paris, 1927[1]

Presque en même temps que Max Ernst, mais dans un esprit assez différent, à première vue quelque peu contraire, Man Ray est parti, lui aussi, de la donnée photographique mais, loin de se fier à elle, de n'utiliser qu'après coup, selon le but qui est le sien, le lieu commun de représentation qu'elle nous propose, il s'est appliqué d'emblée à lui ôter son caractère positif, à lui faire passer cet air arrogant qu'elle avait de se donner pour ce qu'elle n'est pas. Si, en effet, pour le même Raymond Lulle, « le miroir est un corps diaphane disposé à recevoir toutes les figures qui lui sont représentées », on n'en saurait dire autant du cliché photographique, qui commence par exiger de ces figures une attitude propice, quand il ne les surprend pas dans ce qu'elles ont de plus fugitif. Les mêmes réflexions s'appliqueraient du reste à la prise de vue cinématographique, de nature à compromettre ces figures non plus seulement dans l'inanimé, mais encore dans le mouvement. L'épreuve photographique prise en elle-même, toute revêtue qu'elle est de cette valeur émotive qui en fait un des plus précieux objets d'échange [et quand donc tous les livres valables cesseront-ils d'être illustrés de dessins pour ne plus paraître qu'avec des photographies ?], cette épreuve, bien que douée d'une force de suggestion particulière, n'est pas en dernière analyse l'image *fidèle* que nous entendons garder de ce que bientôt nous n'aurons plus. Il était nécessaire, alors que la peinture, de loin distancée par la photographie dans l'imitation pure et simple des choses réelles, se posait et résolvait comme on l'a vu le problème de sa raison d'être, qu'un parfait technicien de la photographie, qui fût aussi de la classe des meilleurs peintres, se préoccupât, d'une part, d'assigner à la photographie les limites exactes à quoi elle peut prétendre, d'autre part de la faire servir à d'autres fins que celles pour lesquelles elle avait été créée, et notamment à poursuivre pour son compte, et dans la mesure de ses moyens propres, l'exploration de cette région que la peinture croyait pouvoir se réserver.

Ce fut le bonheur de Man Ray que d'être cet homme. Aussi jugerais-je vain de distinguer dans sa production ce qui est portraits photographiques, photographies dites fâcheusement abstraites et œuvres picturales proprement dites. Aux confins de ces trois sortes de choses qui sont signées de son nom et qui répondent à une même démarche de son esprit, je sais trop bien que c'est toujours la même apparence, ou inapparence, qui est cernée.

Les femmes très élégantes et très belles qui exposent jour et nuit leurs cheveux aux terribles lumières de l'atelier de Man Ray n'ont certes pas conscience de se prêter à une démonstration quelconque. Comme je les étonnerais en leur disant qu'elles y participent au même titre qu'un canon de quartz, qu'un trousseau de clés, que le givre ou que la fougère ! Le collier de perles glisse des épaules nues sur la page blanche, où vient le prendre un rayon de soleil, parmi d'autres éléments qui sont là. Ce qui n'était que parure, ce qui n'était rien moins que parure est abandonné simultanément au goût des ombres, à la justice des ombres. Il n'y a plus que des roses dans les caves. La préparation ordinaire qu'on fera tout à l'heure subir à la page ne différera en rien de celle qu'on fait subir à l'autre page pour y faire apparaître les plus chers traits du monde. Les deux images vivent et meurent du même tremblement, de la même heure, des mêmes lueurs perdues ou interceptées. Elles sont presque toujours aussi parfaites, il est bien difficile de penser qu'elles ne sont pas sur le même plan, on dirait qu'elles sont aussi nécessaires l'une à l'autre que ce qui touche à ce qui est touché. Sont-ce cheveux d'or ou cheveux d'ange ? Comment reconnaître la main de cire de la vraie main ?

Pour qui sait mener à bien la barque photographique dans les remous presque incompréhensible des images, il y a la vie à rattraper comme on tournerait un film à l'envers, comme on arriverait devant un appareil idéal à faire *poser* Napoléon, après avoir retrouvé son empreinte sur certains objets.

1] *André Breton, « Le Surréalisme et la Peinture », dans* La Révolution Surréaliste, *n° 9–10, 1ᵉʳ octobre 1927, pp. 41–42. Autre édition : André Breton,* Le Surréalisme et la Peinture, *Paris [Gallimard],* 1965.

Man Ray

EMMANUELLE
DE L'ECOTAIS

Créateur de la photographie surréaliste

La période de Man Ray à Paris [1921–1940] constitue la partie la plus intéressante de son œuvre. C'est là que son art original s'est développé et a eu le maximum de répercussions. Paris est à l'époque un centre artistique très important : le mouvement dada, né en 1916 à Zurich, s'est installé dans la capitale française, notamment grâce à l'arrivée de Tristan Tzara. Man Ray, dont l'art aux États-Unis ne parvient pas à s'épanouir, voit en Paris la terre promise. Son plus proche ami aux États-Unis est français : c'est Marcel Duchamp. Celui-ci l'entraîne à sa suite, et le présente à tous ceux qui auront une influence capitale sur le développement de son travail et de sa carrière.

La première personne à avoir joué un rôle considérable dans l'œuvre de Man Ray est donc Marcel Duchamp, et ceci bien avant qu'il ne débarque à Paris. En effet, leur rencontre date de 1915, à Ridgefield, dans le New Jersey. Leur entente est immédiate, et ceci même malgré l'obstacle de la langue. Marcel Duchamp, motivé par son désir d'atteindre « cette peinture de précision et cette beauté d'indifférence » qui le poussa à arrêter de peindre rencontra en Man Ray et son intérêt naissant pour la photographie à la fois un ami et un collaborateur important. Man Ray lui-même tâchait alors de faire évoluer sa peinture vers une réalisation en aplat, probablement motivée par la découverte de la photographie. Ses aérographes [depuis 1917], ces peintures vaporisées, procèdent du même principe d'abandon des techniques picturales classiques. Avec sa nouvelle passion pour la photographie, Man Ray devait trouver en Marcel Duchamp un supporter convaincu. Ou plutôt tous deux découvrirent-ils ensemble dans la photographie un moyen de création idéal, satisfaisant en eux ce besoin « d'optique de précision » qui allait justement donner naissance chez Duchamp à différentes recherches sur l'optique [*Rotative plaques de verre*, 1920], mais également à certaines parties du *Grand Verre* [1915–1923] comme *Les Pistons de cou-*

rant d'air [1914], dont on sait que la réalisation photographique lui fut suggérée par Man Ray. Prenons par exemple la création de Rrose Sélavy par Marcel Duchamp : l'idée même de cette imposture ne serait-elle pas venue à l'esprit de Duchamp grâce à la présence d'un photographe dans son entourage ? Quoi de mieux qu'une photographie pour rendre réel, cautionner, donner un certificat d'authenticité à un fait, un événement ou en l'occurrence à l'existence d'une personne ? Réciproquement, ne peut-on voir dans les recherches de Man Ray sur les ombres [*Integration of Shadows*, 1919, ill. p. 9] et les machines [*La femme*, 1920, ill. p. 8] une influence du travail de Marcel Duchamp sur les ombres portées et la mécanique du Grand Verre ? Marcel Duchamp et Man Ray se rejoignent aussi sur un point : pour un artiste, le plus important est d'exprimer une idée, la technique employée ne constituant pas un but en soi, mais un moyen d'atteindre ce but : « Mon but était de me tourner vers l'intérieur, plutôt que vers l'extérieur », dit Marcel Duchamp. Et il poursuit : « Dans cette perspective, j'en vins à penser qu'un artiste pouvait employer n'importe quoi [...] pour exprimer ce qu'il voulait dire[1]. » Or de fait, tous deux se sont « éloignés de l'acte physique de la peinture[2]». Marcel Duchamp explique qu'il voulait «revenir à un dessin absolument sec, à la composition d'un art sec» dont le « dessin mécanique» était «le meilleur exemple[3]». Et c'est exactement ce que fit Man Ray avec les aérographes, avec les clichés verre et la photographie.

Cette entente parfaite devait conduire Man Ray à suivre son ami à Paris. L'échec cuisant de la revue *New York Dada* qu'il créèrent à New York ne fut pour l'Américain qu'une confirmation : seule la capitale française était « prête » à accueillir son esprit profondément dada.

C'est le soir du 22 juillet 1921 que Man Ray y rencontre grâce à Marcel Duchamp, tout le groupe dada : André Breton, Jacques Rigaut, Louis Aragon, Paul Éluard et sa femme Gala, Théodore Fraenkel et Philippe Soupault. Surprise pour Man Ray : aucun d'entre eux n'est peintre. Ils sont tous poètes ou écrivains. De fait, il n'existe aucune influence de la part de ces artistes sur l'œuvre de Man Ray. En revanche, André Breton, qui dirige la revue *Littérature*, voit tout de suite comment Man Ray va pouvoir lui être utile. En tant que photographe, il devient

1] *Marcel Duchamp, Entretien avec James Johnson Sweeney, repris par Michel Sanouillet dans :* Duchamp du signe, *nouvelle édition, Paris* [Flammarion] 1975, *p.* 171.

2] Ibidem

3] Ibidem

vite indispensable à l'éditeur, qui le contacte régulièrement pour l'envoyer chez des artistes photographier les travaux qu'il veut reproduire. Man Ray va tirer parti de cette tâche de deux manières : d'une part il profite de chaque séance pour faire le portrait de l'artiste en question, d'autre part il demande en échange à André Breton, qui ne le paye pas, de reproduire ses propres travaux dans sa revue. Son expérience déjà affirmée dans le portrait [il avait obtenu un prix pour le portrait de Berenice Abbott au *Fifteenth Annual Exhibition of Photgraphs* de Philadelphie, en mars 1921] et le « bouche à oreille » fonctionnèrent si bien qu'en très peu de temps Man Ray rencontra toutes les personnalités parisiennes du moment, chacune amenant d'autres clients : Gertrude Stein lui présenta Pablo Picasso et Georges Braque ; Jean Cocteau toute l'aristocratie aisée en quête d'un portraitiste original. De fil en aiguille, l'atelier de Man Ray devient même le lieu de pèlerinage des étrangers à Paris. Le portrait des dames de la haute société parisienne servant souvent de photographie de mode dans les années 1920, Man Ray entre en contact notamment avec le couturier Paul Poiret, puis dès 1924 commence à travailler régulièrement pour *Vogue*. Son succès est d'autant plus grand que parallèlement il publie ses travaux plus personnels dans *Littérature, Les Feuilles Libres, The Little Review* et même *Vanity Fair*.

Le déclencheur de ce succès est sans aucun doute sa découverte de la rayographie à la fin de l'année 1921 ou au début de l'année 1922. Puis Man Ray se fera le champion des manipulations photographiques, avec notamment la surimpression et la solarisation, toutes deux valorisant la photographie créative aux dépens de la photographie pure qui prévalait alors à Paris. Contrairement aux photographes de son temps, qui veulent mettre en valeur l'Homme Moderne au moyen d'une technique moderne, sans la « trafiquer », Man Ray utilise la photographie comme n'importe quel autre médium. Il recadre, retouche[4], imprime en négatif, renverse ou inverse les images ; il photographie même sans appareil, bref ! Man Ray invente la photographie surréaliste.

Ce qu'on appelle généralement « photogramme » ou « rayographie » est un procédé simple qui consiste à poser directement sur du papier sensible des objets et à les exposer à la lumière pendant quelques secondes. En développant ensuite normalement le papier, on obtient une

4] *Voir à ce sujet* La photographie à l'envers, *Musée national d'art moderne, Centre Georges Pompidou Paris [Le Seuil]* 1998.

image dont les valeurs sont inversées. Man Ray raconta qu'il avait découvert ce procédé lors d'une séance de développement en chambre noire de photographies de mode pour Paul Poiret. Mais ses explications, bien qu'amusantes, ne sont pas convaincantes. Il existe chez Man Ray une volonté évidente de cacher ses processus de création, motivée par une de ses profondes convictions selon laquelle l'important n'est pas la technique employée, mais l'œuvre finale. Man Ray disait même qu' «un certain mépris pour le moyen physique d'exprimer une idée est indispensable pour la réaliser au mieux[5]». L'anecdote concernant cette découverte soi-disant due au hasard est donc sans importance. En revanche, on sait que Tristan Tzara, alors un proche ami de Man Ray, possédait une collection de schadographies réalisées vers 1918–1919 par Christian Schad [1894–1982]. Ce dernier faisait partie du groupe dada de Zurich, et s'était lui-même inspiré des premiers travaux de Henry Fox Talbot[6]. Christian Schad utilisait du papier à noircissement direct: «Un support très peu sensible, que l'on pouvait préparer à vue, en lumière atténuée, et qui était ensuite exposé au soleil. L'avantage de ce procédé était de ne pas nécessiter de chambre noire[7].» Man Ray, lui, allait réaliser ses rayographies en chambre noire : « Ce n'est qu'après avoir été développée puis fixée que l'épreuve pouvait être observée au grand jour. La principale raison de ce choix reposait vraisemblablement sur la possibilité de modifier à volonté l'intensité ou la direction de la lumière[8].» En outre, Christian Schad ne posait sur le papier sensible que des papiers découpés ou des objets plats, et réalisait ainsi des images proches des collages cubistes. Man Ray de son côté utilisa toutes sortes d'objets en trois dimensions et notamment des objets en verre, dont les ombres portées ou la translucidité permettaient d'obtenir des valeurs différentes dans les noirs et les blancs. La présence d'épreuves de Christian Schad dans la collection d'un ami proche de Man Ray peut donc laisser supposer qu'il ne «découvrit» pas cette technique par hasard comme il l'expliqua, mais qu'il s'inspira des recherches de Christian Schad pour créer un nouveau mode d'expression.

Les expériences de Man Ray en laboratoire sont compatibles avec ses recherches antérieures : Man Ray avait montré, dans ses images faites à New York, son souci d'exprimer de manière « sensible », donc au

5] *Man Ray, « L'Âge de la Lumière », dans :* Minotaure, 1933, *n° 3-4 p.* 1.

6] *William Henry Fox Talbot [1800-1877] réalisa dès 1834-1835 des empreintes d'objets sur du papier sensibilisé au chlorure d'argent qu'il intitula « dessins photogéniques ».*

7] *Floris M. Neusüss et Renate Heyne, dans :* Laszlo Moholy-Nagy, compositions lumineuses, 1922–1943, *Paris, Centre Georges Pompidou,* 1995, *pp.* 14-15.

8] Ibidem

moyen de la photographie, la vie des objets, leur indépendance, leur capacité à signifier autre chose que ce pour quoi ils avaient été fabriqués : *La femme* [1920, ill. p. 8] est un batteur à œufs dont la signification est transformée par le biais des titres. Il y a d'autres versions avec le titre *Man* [1918] ou *L'Homme*. La rayographie procède du même principe. Il s'agit là de donner une autre apparence aux choses. Les objets posés par Man Ray sur le papier sensible sont souvent reconnaissables, tout en étant transformés, transportés dans un monde étranger. C'est précisément ce rapport, cette dialectique entre le connu et l'inconnu qui permet d'ouvrir l'esprit à une autre réalité.

Les rayographies furent les premières épreuves photographiques à acquérir auprès du plus grand nombre une valeur équivalente à celle de la peinture. Comme il l'explique dans son *Autoportrait*, Man Ray essayait « de faire en photographie ce que faisaient les peintres, avec cette différence [qu'il utilisait] de la lumière et des produits chimiques au lieu de couleurs et cela sans le secours de l'appareil photo[9] ». La rayographie prouvait que la photographie, contrairement aux idées reçues, n'était pas simplement reproductrice, documentaire, mais également créatrice, inventive, et qu'elle pouvait donner naissance à des images nées de l'imagination, de l'inspiration et de la réflexion de l'artiste.

Les mots que l'on retrouve le plus souvent dans les articles de l'époque pour qualifier Man Ray ou ses rayographies sont « poète », « poésie », « poétique ». Parce que du point de vue technique, ces images sont le résultat d'une véritable écriture sur le papier sensible. Une impression de mouvement est obtenue en exposant plusieurs fois les objets à des sources lumineuses différentes. Man Ray écrit avec une ampoule comme le poète écrit avec un stylo. La lumière blanche a remplacé l'encre noire. Man Ray devient le poète par excellence, qui écrit avec la lumière.

Au début de l'année 1922, les rayographies de Man Ray sont considérées comme des œuvres du plus pur dada. Le titre de son album de douze rayographies *Champs délicieux* était fortement inspiré du titre du texte d'André Breton et Philippe Soupault, *Les champs magnétiques* [1920]. Mais celui-ci ayant été considéré *a posteriori* par André Breton lui-même comme le premier texte surréaliste, les rayographies, par ana-

9] *Man Ray*, Autoportrait, *Paris* 1963, *p.* 120.

logie, sont souvent considérées comme les premières œuvres photographiques surréalistes. Or les rayographies ne sont pas des œuvres surréalistes – on soulignera d'ailleurs que le surréalisme naquît en 1924 –, mais des œuvres d'esprit dada, fondées sur le principe de « projection destructive » de « tout art formel », pour reprendre une expression de Georges Ribemont-Dessaignes. Les objets sont projetés dans un univers inconnu, et nous sont montrés par le biais d'un art nouveau : la rayographie. La création de cet art permet d'évincer les arts classiques, et son mode de représentation permet d'évincer les modes réalistes ou abstraits qui existaient jusque-là. En peinture notamment, la représentation abstraite n'était pas envisagée comme une possibilité acceptable pour les dadaïstes ; car tant que subsisteraient les moyens classiques de création, Dada ne serait pas. Man Ray parvenait à donner, au moyen d'un nouveau procédé, une vision nouvelle d'objets pourtant usuels. Agencés, disposés les uns en fonction des autres, leur association permettait de créer une « poésie plastique». Non pas une image de rêve, comme on le dira plus tard sous l'influence du surréalisme, mais l'image d'une autre réalité, nouvelle, inconnue et toutefois distincte, visible et presque palpable, grâce à l'écriture de la lumière, grâce au médium photographique. Les rayographies n'étaient pas abstraites, puisqu'elles étaient l'enregistrement par contact d'objets réels. L'inconscient n'a pas sa place ici, car l'agencement des objets est raisonné, et ce n'est pas le monde du rêve qui est représenté, mais bien une réalité, autre certes, mais effective.

Le parallèle avec l'écriture automatique de Breton et Soupault dans *Les Champs magnétiques* renvoyait donc uniquement au procédé technique de l'œuvre. André Breton disait en 1921 : « L'écriture automatique apparue à la fin du XIXᵉ siècle est une véritable photographie de la pensée[10].» Il s'agissait donc ici de l'idée, et non pas du rêve, de l'inconscient ou des forces obscures comme cela fut expliqué *a posteriori*. Le rapport entre *Champs délicieux* et *Les Champs magnétiques* doit donc être considéré en fonction de l'impact qu'avait eu le texte d'André Breton et de Philippe Soupault en 1920, impact qui s'inscrivait alors en pleine période dada.

D'autres techniques firent le succès de Man Ray et le lièrent au mouvement surréaliste : la surimpression et la solarisation. Ce qu'on

10] A. Breton, Exposition Dada Max Ernst, *Paris* [*Au Sans Pareil]* 1921.

appelle la surimpression est la superposition de deux négatifs [dans l'agrandisseur ou même au moment de la prise de vue]. Cette technique permet de retranscrire un mouvement, un relief ou de juxtaposer deux éléments de manière à leur donner une signification particulière, comme cela peut être le cas dans un portrait [*Tristan Tzara*, 1921]. Man Ray utilisa beaucoup cette technique, mais c'est davantage grâce à la solarisation qu'il s'imposa comme un des plus grands photographes à Paris.

Techniquement la solarisation se définit comme l'inversion partielle des valeurs sur une photographie, accompagnée d'un liséré caractéristique. Obtenue en allumant la lumière au moment du développement, elle était jusque-là considérée comme un accident de laboratoire. Man Ray maîtrise ce procédé dès 1929, et l'applique à un grand nombre de portraits, de nus et de photographies de mode. Son succès est immédiat, car il obtient ainsi un effet saisissant et très étonnant pour l'époque : une sorte de matérialisation de l'aura. Celle-ci, pour les sciences occultes, n'est en principe visible que par les seuls initiés. Man Ray, contrairement aux surréalistes, ne fut pas un adepte du spiritsme, pourtant il fut considéré comme un photographe surréaliste en partie en raison de cette pratique. En outre, ce n'est pas grâce au surréalisme que Man Ray développa son art photographique, comme on l'a souvent dit, mais c'est plutôt grâce à Man Ray que le surréalisme se développa en photographie : en effet, alors qu'il s'inscrivait dans la mouvance dada, Man Ray donnait déjà une vision poétique des objets, un des thèmes de prédilection du surréalisme. Dada encore, il abordait le médium photographique comme un art créatif détaché de la réalité, un outil permettant toute liberté de réalisation, dont le statut documentaire lui-même devenait source de jeu [*Rrose Sélavy*, 1921]. Avec un instrument censé reproduire fidèlement la nature, il photographia dès 1920 des paysages fantasmagoriques [« Voici le domaine de Rrose Sélavy… » [11], dit *Élevage de poussière*, ill. p. 117]. Enfin, dès 1920, Man Ray produisait des images où l'érotisme et la transformation étaient patents. Car si Rosalind Krauss[12] relève l'importance de l'image *Head, New York* dans ce que plus tard Georges Bataille et après lui les photographes surréalistes appelèrent « l'informe », il faut souligner ici que la date de cette image est 1920. Le surréalisme naquit quatre ans plus tard.

11] *Élevage de poussière est un titre donné par Marcel Duchamp beaucoup plus tard. La photo paraît pour la première fois en octobre 1922 dans le numéro 5 de* Littérature, *sous le titre : « Voici le domaine de Rrose Sélavy / Comme il est aride – comme il est fertile – / comme il est joyeux – comme il est triste ! » et signée « Vue prise en aéroplane par Man Ray », ce qui donnait à son travail technique l'aspect d'une acrobatie, et trompait le lecteur pour lequel le dessin géométrique apparent sous la poussière devenait les lignes de délimitation des champs d'un « domaine », celui de Rrose Sélavy.*

12] *Dans « Corpus delicti »,* dans : Le Photographique, Pour une Théorie des Écarts, *Paris [Macula] 1990, p.* 164-165.

En réalité, Man Ray fut d'une part le seul photographe qui soit passé de Dada au surréalisme, d'autre part le premier photographe à être proche du mouvement surréaliste, au point d'être le seul dans cette position pendant près de cinq ans: la première revue surréaliste, *La Révolution Surréaliste*, ne publie pratiquement que des images de Man Ray. Les quelques autres photographies utilisées sont pour la plupart des images trouvées chez les brocanteurs ou même dans des revues populaires ou scientifiques, donc anonymes. La volonté d'une réalisation « automatique » de l'art préside à la pensée bretonienne. La photographie, forme instantanée de création, devient le médium idéal face à la peinture qui nécessite un temps de gestation, laissant le raisonnement entraver l'accès direct à l'inconscient. Mais Man Ray, bien avant les surréalistes, avait compris la puissance de création de la photographie. Son essence documentaire, son apparent attachement au réel avait dès le début inspiré une conscience déjà aiguë de « l'irréalité contenue dans la réalité même ».

Les techniques que Man Ray utilisa à Paris connurent un succès immédiat. Le photogramme et la solarisation se répandirent en France puis dans toute l'Europe comme un traînée de poudre. Le rôle des artistes français dans cette réussite fut équivalent à celui d'un galeriste ou d'un éditeur – ce qu'ils étaient d'ailleurs, pour la plupart : grâce à eux, Man Ray publia ses travaux dans de nombreuses revues des mouvements dada et surréaliste [*Littérature, Mécano, Merz, La Révolution Surréaliste, Le Surréalisme au service de la Révolution, Minotaure*, etc.]. Man Ray lui-même ne se considérait pas comme « dadaïste », bien que son œuvre, très certainement, est générée par un esprit dada. Il n'entre donc pas dans une catégorie particulière d'artistes, ni même dans un mouvement. Man Ray est inclassable.

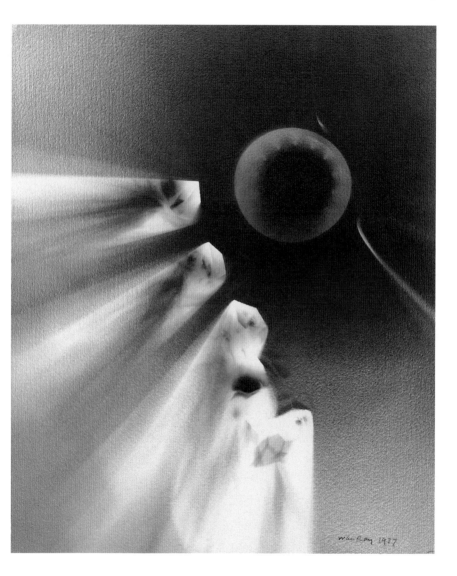

Rayograph
1927

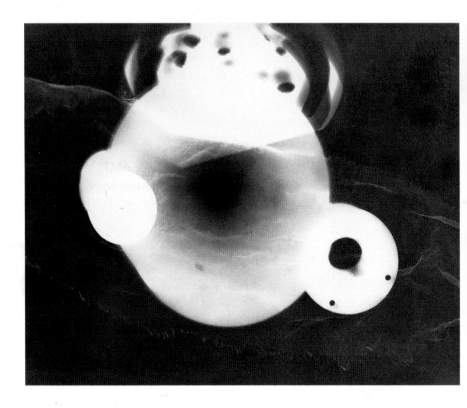

Rayograph
1926

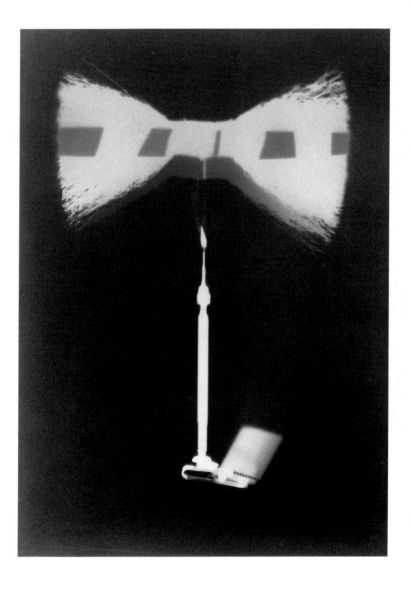

Rayograph
1921–22

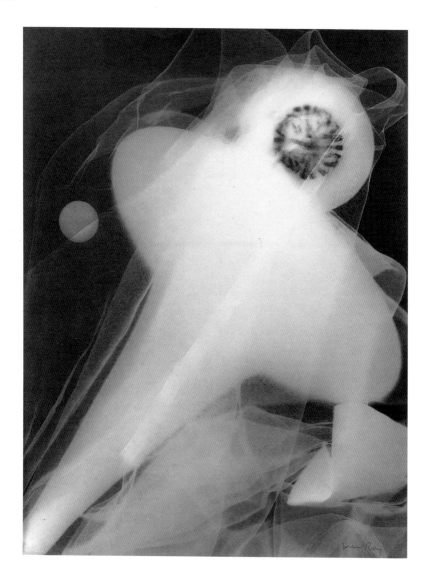

Rayograph
1925

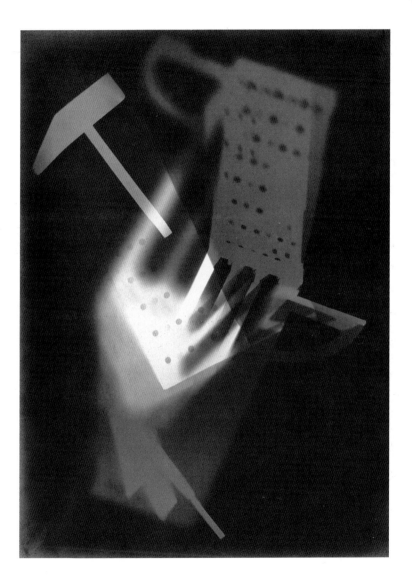

Rayograph
c. 1928

Für mich gibt es keinen Unterschied zwischen Traum und Wirklichkeit. Ich weiß nie, ob das, was ich mache, ein Produkt des Traums oder des Wachseins ist.

For me there's no difference between dream and reality. I never know if what I'm doing is done when I'm dreaming or when I'm awake.

Pour moi, il n'y a pas de différence entre le rêve et la réalité. Je ne sais jamais si ce que je fais est le produit du rêve ou de l'éveil.

Rayograph
1922

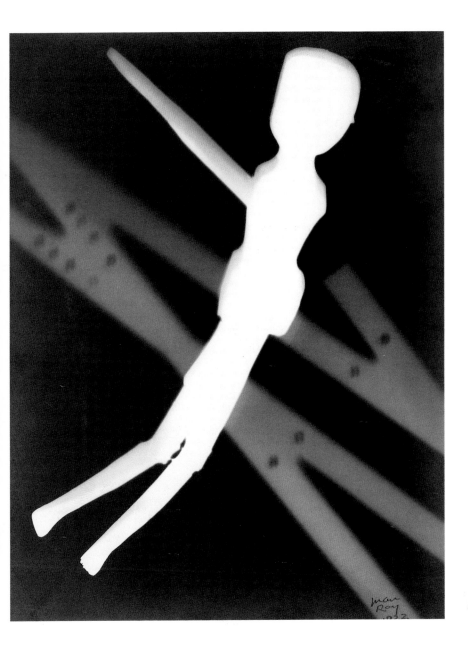

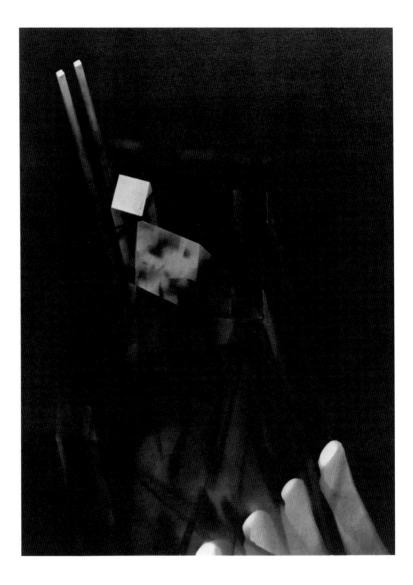

Rayograph
1922

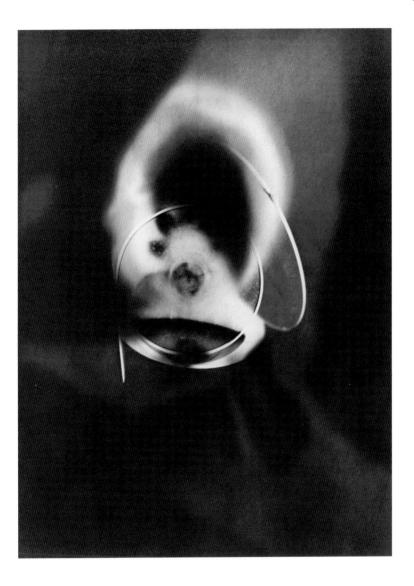

Rayograph
1922-23

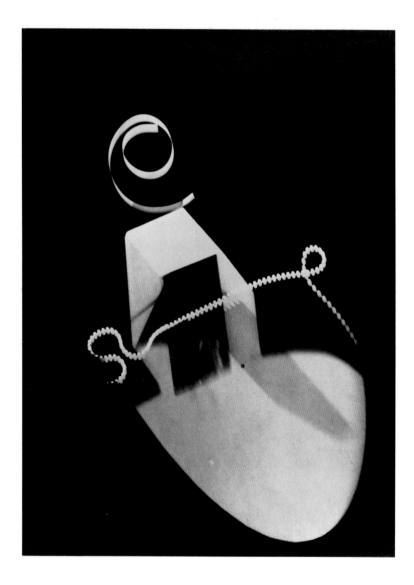

Rayograph
c. 1927

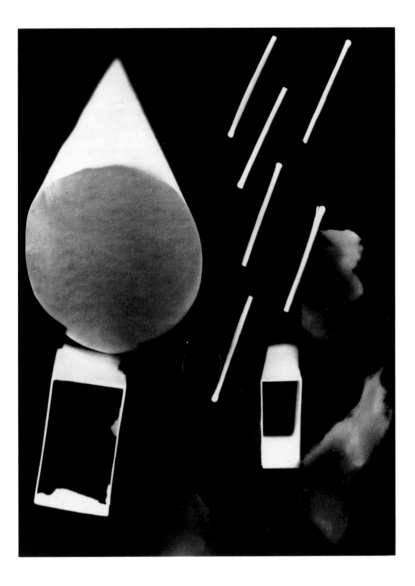

Rayograph
1925

Alles kann durch das Licht verändert, deformiert oder eliminiert werden. Es ist genauso geschmeidig wie der Pinsel.

Everything can be transformed, deformed, and obliterated by light. Its flexibility is precisely the same as the suppleness of the brush.

Tout peut être transformé, déformé, éliminé par la lumière. Sa souplesse est la même que celle du pinceau, exactement.

Rayograph
1925

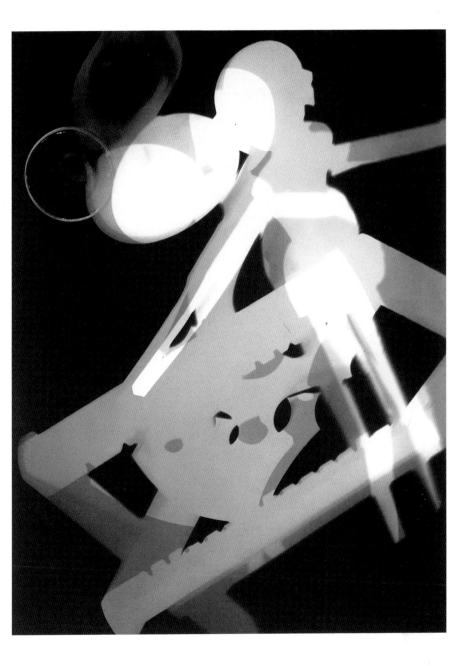

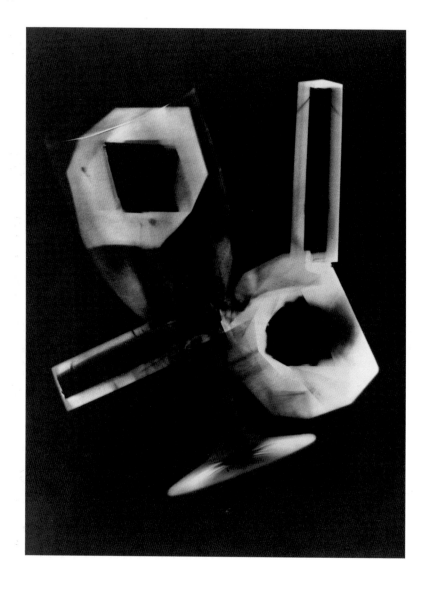

Rayograph
1925

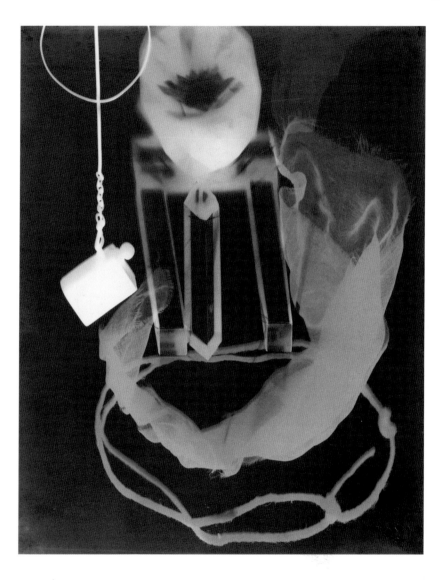

Rayograph
1923

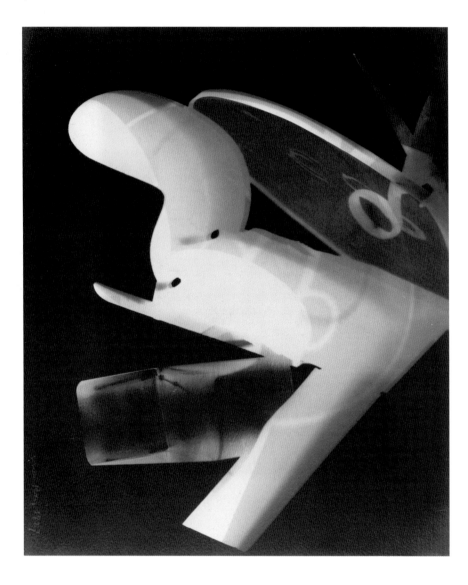

Rayograph
1927

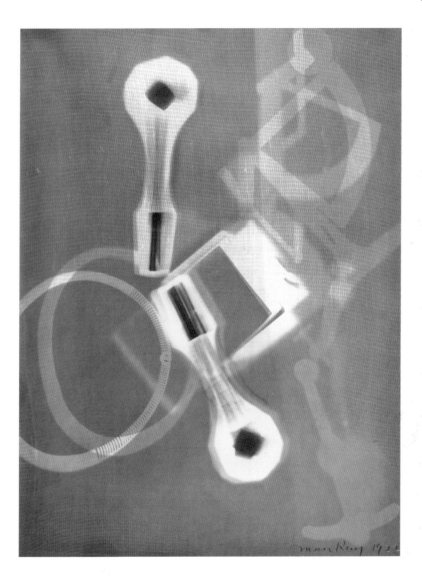

Rayograph
1922

Wie die unberührte Asche eines von Flammen verzehrten Objekts sind diese
Bilder durch Licht und Chemikalien fixierte oxydierte Rückstände einer
Erfahrung, eines Abenteuers, nicht eines Experiments. Sie gehen auf Neu-
gier, auf Inspiration zurück, und diese Worte geben nicht vor, irgendeine
Information vermitteln zu wollen.

*Like the undisturbed ashes of an object consumed by flames, these images are oxidized
residues fixed by light and chemical elements of an experience, an adventure, not an
experiment. They are the result of curiosity, inspiration, and these words do not pretend
to convey any information.*

Telles les cendres inertes d'un objet consumé par le feu, ces images forment
des résidus oxydés dus à l'action de la lumière et des éléments chimiques, des
vestiges d'une expérience vécue, d'une aventure, mais non pas d'une expéri-
mentation. Elles ont pour origine la curiosité, l'inspiration – deux termes
qui ne prétendent pas transmettre davantage de renseignements.

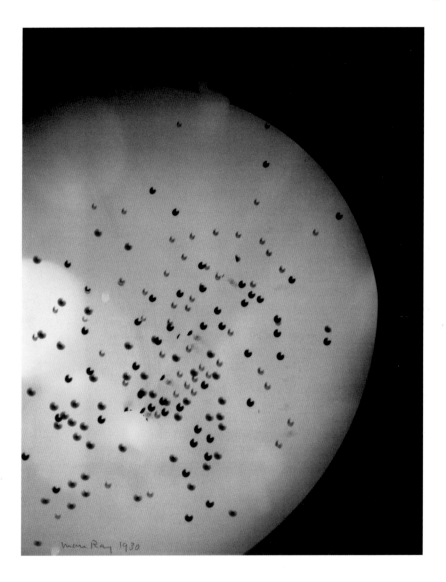

Rayograph
1930

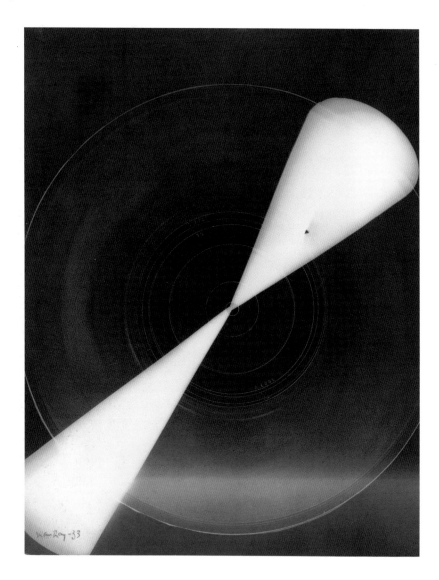

Rayograph
1933

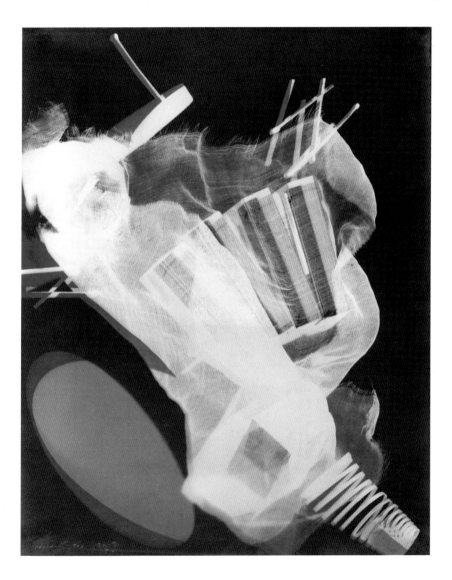

Rayograph
1922

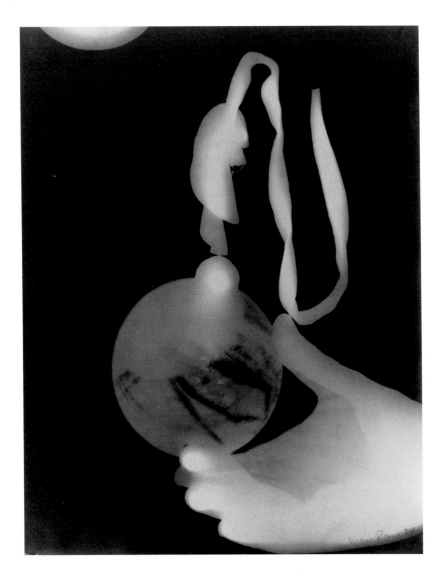

Rayograph
1924

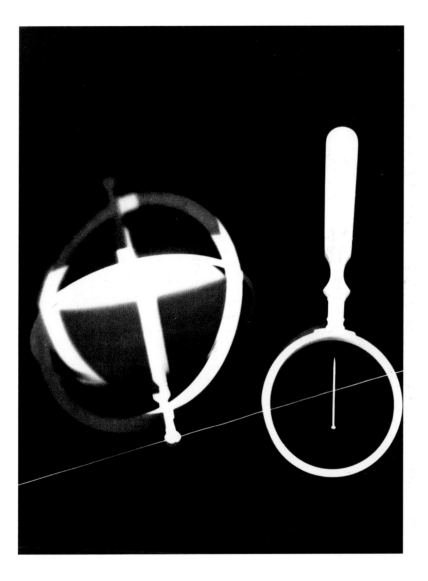

Rayograph
1922

Ist die Fotografie eine Kunst? Man muß nicht herausfinden, ob sie eine Kunst ist. Kunst ist überholt. Wir brauchen etwas anderes. Man muß sich nur anschauen, wie das Licht arbeitet. Das Licht ist schöpferisch. Ich setze mich vor mein empfindliches Blatt Papier und denke nach.

Is photography an art? There's no point trying to find out if it's an art. Art is a thing of the past. We need something else. You've got to watch light at work. It's light that creates. I sit down in front of my sheet of photographic paper and I think.

La photographie est-elle un art ? Il n'y a pas à chercher si c'est un art. L'art est dépassé. Il faut autre chose. Il faut regarder travailler la lumière. C'est la lumière qui crée. Je m'assieds devant ma feuille de papier sensible et je pense.

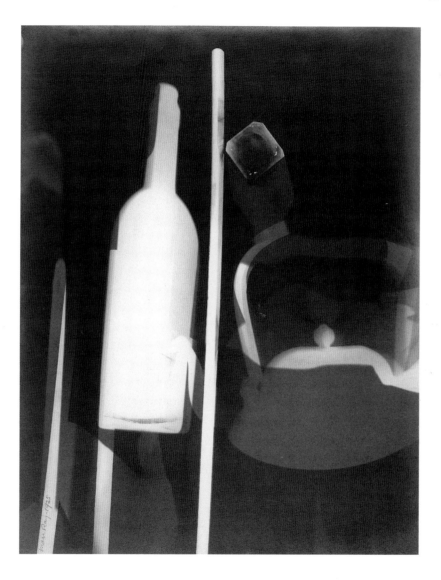

Rayograph
1925

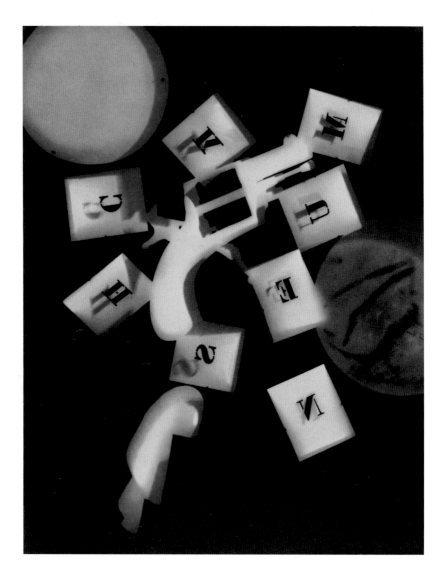

Rayograph
1924

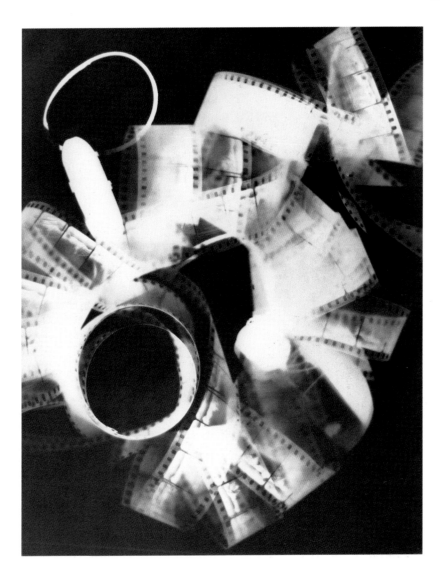

Rayograph
1930

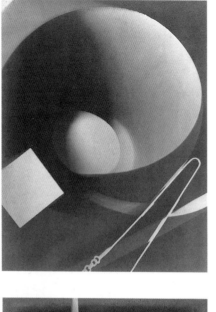
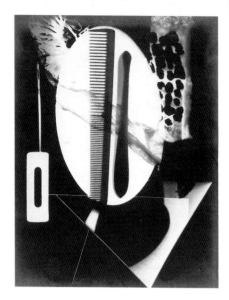
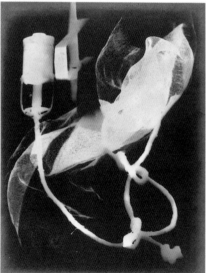
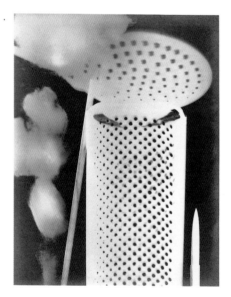

Champs délicieux
1922

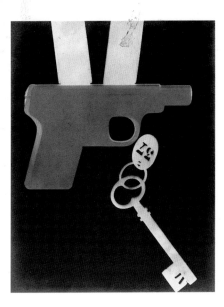
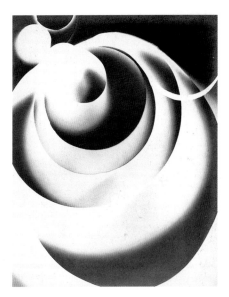
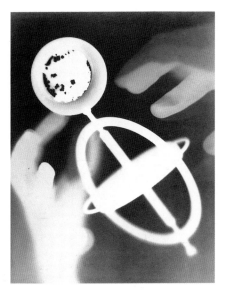
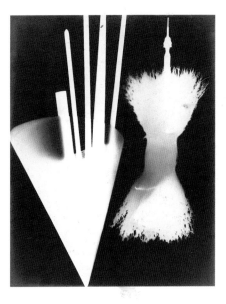

Champs délicieux
1922

Ich bleibe dabei: Die Fotografie ist keine Kunst.

I maintain that photography is not artistic.

Je persiste à croire que la photographie n'est pas de l'art.

Marcel Duchamp
1916

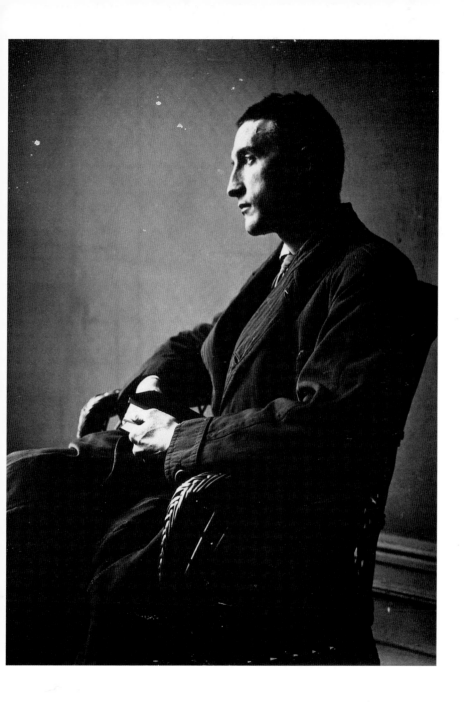

Alberto Giacometti
c. 1934

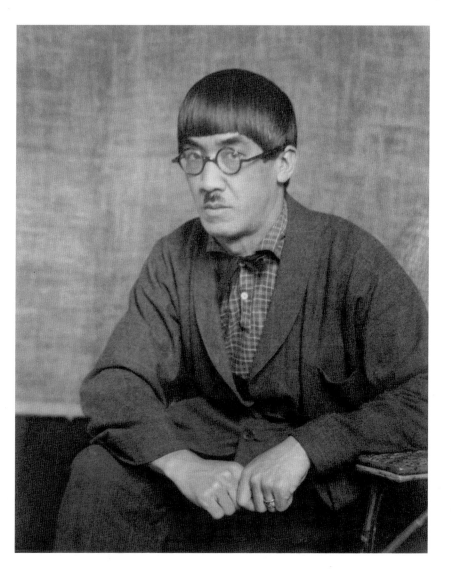

Tsugouharu Foujita
1922

Erst beim Fotografieren meiner Gemälde habe ich entdeckt, was in ihnen steckte, und das kam erst bei der Schwarzweißreproduktion heraus. Eines Tages habe ich das Gemälde zerstört und das Foto behalten. Seitdem überzeuge ich mich immer wieder aufs neue, daß die Malerei ein veraltetes Ausdrucksmittel ist und von der Fotografie entthront werden wird, sobald die visuelle Erziehung des Publikums vollzogen ist.

It was when I photographed my canvases that I discovered the value they acquired from black-and-white reproduction. One day I just destroyed the picture and kept the proof. Ever since, I've been trying to convince myself that painting is an outmoded type of expression, and that photography will usurp it when the public has finally been visually educated.

C'est en photographiant mes toiles que j'ai découvert la valeur qu'elles prenaient à la reproduction en noir et blanc. Un jour est venu où j'ai détruit le tableau et gardé l'épreuve. Depuis je n'ai cessé de me persuader que la peinture est un moyen d'expression désuet et que la photographie la détrônera quand l'éducation visuelle du public sera faite.

Max Ernst
c. 1934

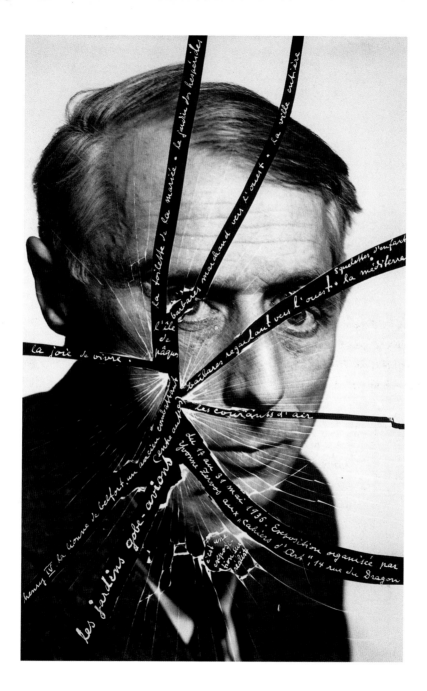

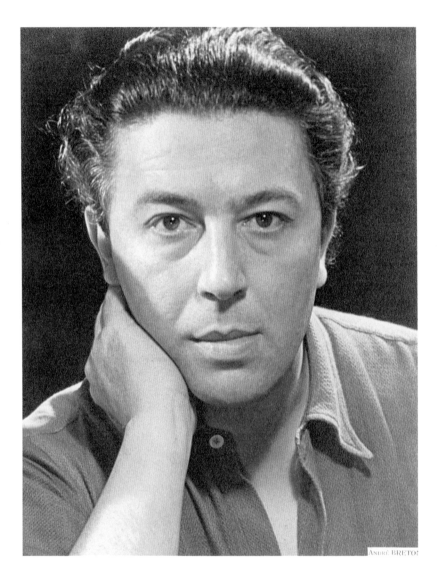

André Breton
c. 1930

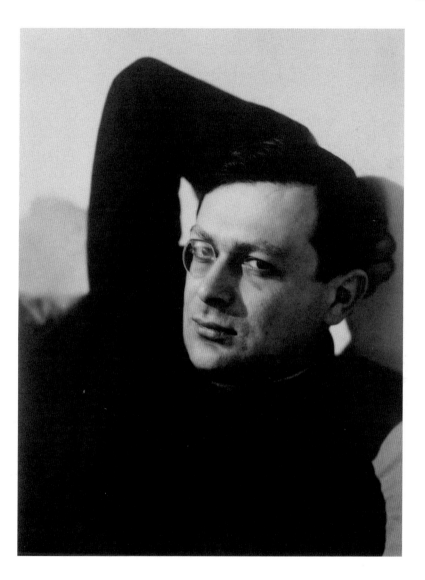

Tristan Tzara
1934

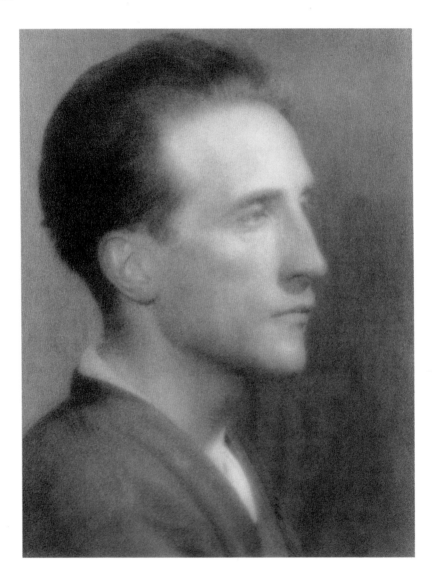

Marcel Duchamp
1920

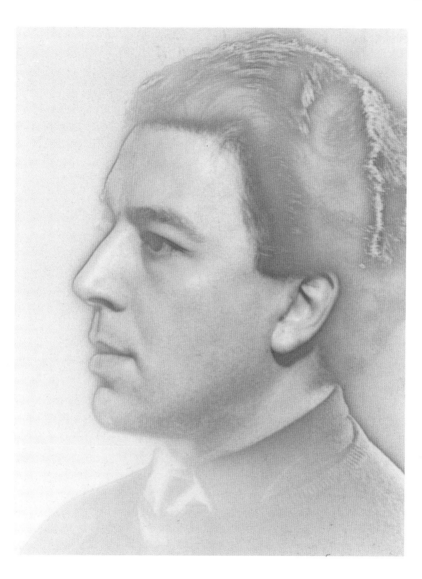

André Breton
c. 1930

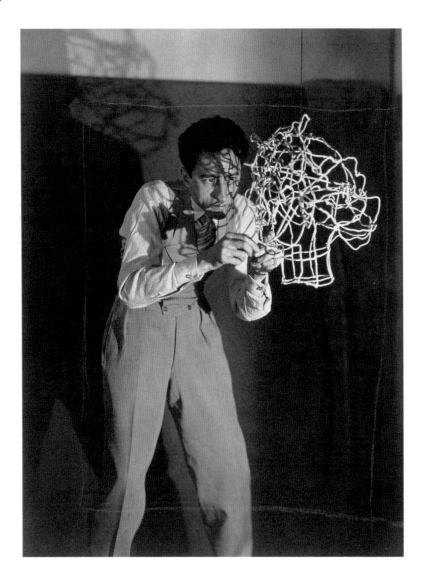

Jean Cocteau, sculpting his own Head in Wire
c. 1925

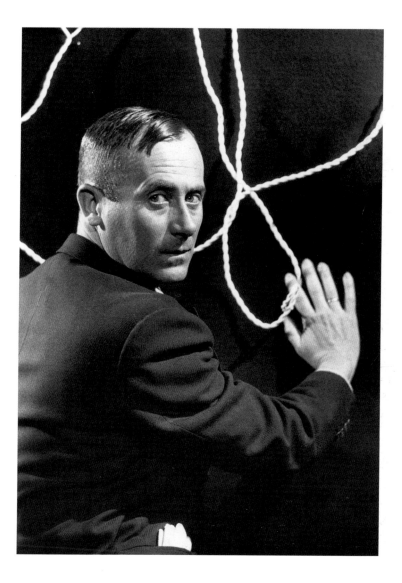

Joan Miró
c. 1930

Ich kenne nur eines: die Möglichkeit, mich auf die eine oder andere Weise auszudrücken. Die Fotografie gibt mir diese Möglichkeit; sie ist ein sehr viel einfacheres und schnelleres Medium als die Malerei.

I know just one thing: how I express myself, in one way or another. Photography offers me the means, more simply and faster than painting.

Je ne connais qu'une chose : le moyen de m'exprimer d'une manière ou d'une autre. La photographie m'en donne le moyen, un moyen bien plus simple et bien plus rapide que la peinture.

Pablo Picasso
1932

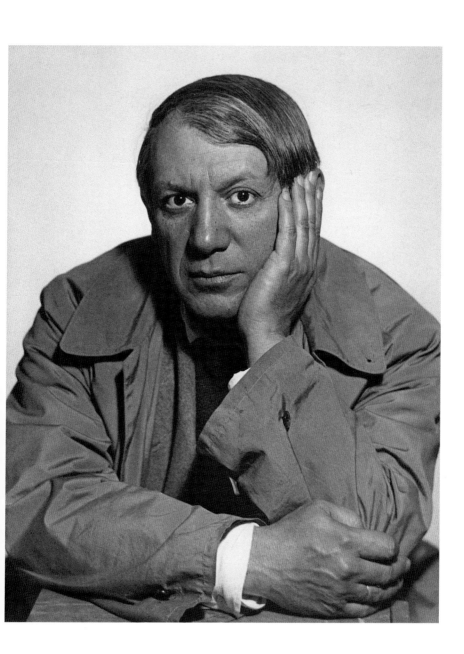

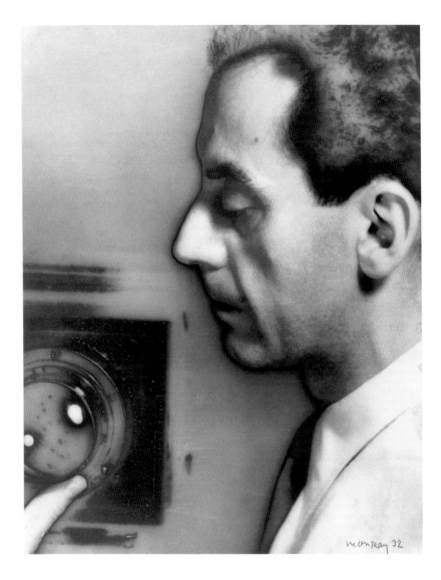

Self-Portrait
1932

Man Ray

Biography | Biographie

1890–1976

1890]

Emmanuel Rudnitzky born in Philadelphia on August 27.

Emmanuel Rudnitzky wird am 27. August in Philadelphia geboren.

Naissance d'Emmanuel Rudnitzky à Philadelphie le 27 août.

1897]

Family moves to Brooklyn.

Die Familie zieht nach Brooklyn.

Déménagement de la famille à Brooklyn.

1908]

Graduates from high school. Offered scholarship to study architecture but decides to become an artist. Works in New York as a draftsman and graphic designer.

Er beendet die High-School. Ein Stipendium für ein Architekturstudium lehnt er ab, um Künstler zu werden. Er arbeitet in New York als Zeichner und Grafiker.

Man Ray termine ses études secondaires. Il se voit offrir une bourse pour poursuivre des études d'architecture mais décide de devenir artiste. Travaille à New York comme dessinateur et graphiste.

1910]

Enrolls in life drawing classes at the National Academy of Design, New York. Visits the gallery of Alfred Stieglitz [1864–1946].

Er belegt Aktzeichenklassen an der National Academy of Design, New York. Er besucht die Galerie von Alfred Stieglitz [1864–1946].

Suit des cours de dessin d'après nature à la National Academy of Design de New York. Fréquente la galerie d'Alfred Stieglitz [1864–1946].

1911]

Attends anatomy classes at the Art Students' League, New York.

Er belegt Anatomiezeichenkurse an der Art Students' League in New York.

Suit des cours d'anatomie à l'Art Students' League de New York.

1912]

Studies at the Ferrer Center, New York. Begins to sign work as "Man Ray".

Er studiert am Ferrer Center, New York. Er beginnt mit »Man Ray« zu signieren.

Études au Ferrer Center à New York. Commence à signer ses œuvres sous le nom de «Man Ray».

1913]

Visits *Armory Show* in New York. Moves to artists' colony in Ridgefield, New Jersey. Meets Belgian writer Adon Lacroix [1886–1980].

Er besucht die *Armory Show* in New York. Er zieht in die Künstlerkolonie in Ridgefield, New Jersey, und lernt die belgische Schriftstellerin Adon Lacroix [1886–1980] kennen.

Voit l'*Armory Show* à New York. S'installe dans la petite colonie d'artistes de Ridgefield, dans le New Jersey. Rencontre la femme écrivain belge Adon Lacroix [1886–1980].

1914]
Marries Adon Lacroix. About this time, acquires first camera to photograph his artworks.

1915]
Meets the collector Walter Arensberg [1878–1954], who introduces him to Marcel Duchamp [1887–1968]. First one-man exhibition at the Daniel Gallery, New York. Moves back to New York.

1916]
With Arensberg and Duchamp, founds the Society of Independent Artists. Second one-man exhibition at the Daniel Gallery.

1917]
Society of Independent Artists exhibition held in New York. Creates aerographs, pictures made with an airbrush. The American photographer Alvin Langdon Coburn [1882–1966] begins making vortographs in London.

1919]
Third one-man exhibition at the Daniel Gallery features aerographs. Separates from Lacroix.

1920]
Joins with Duchamp and Katherine Dreier [1877–1952] to establish the Société Anonyme, the first museum devoted to modern art. Begins freelance work for Harper's Bazaar. Exhibition of his photographs at the Salon Dada: Exposition Internationale in Paris.

Er heiratet Adon Lacroix. Um diese Zeit kauft er seine erste Kamera, um seine Gemälde zu fotografieren.

Er lernt den Sammler Walter Arensberg [1878–1954] kennen, der ihn mit Marcel Duchamp [1887–1968] bekanntmacht. Erste Einzelausstellung in der Daniel Gallery, New York. Er zieht zurück nach New York.

Zusammen mit Arensberg und Duchamp gründet er die Society of Independent Artists. Zweite Einzelausstellung in der Daniel Gallery.

Ausstellung der Society of Independent Artists in New York. Mit Hilfe einer Spritzpistole fertigt er Aerografien. Der amerikanische Fotograf Alvin Langdon Coburn [1882–1966] fertigt in London die ersten Vortografien.

In der dritten Einzelausstellung in der Daniel Gallery werden Aerografien gezeigt. Man Ray trennt sich von Adon Lacroix.

Zusammen mit Duchamp und Katherine Dreier [1877–1952] gründet er die Société Anonyme, um das erste Museum für moderne Kunst aufzubauen. Beginn der Tätigkeit als freischaffender Fotograf für Harper's Bazaar. Im Salon Dada: Exposition Internationale in Paris stellt er Fotografien aus.

Mariage avec Adon Lacroix. À cette époque, achète son premier appareil pour photographier ses peintures.

Rencontre le collectionneur Walter Arensberg [1878–1954], qui lui présente Marcel Duchamp [1887–1968]. Première exposition individuelle à la Daniel Gallery à New York. Retourne vivre à New York.

Fondation de la Society of Independent Artists [Société des artistes indépendants] avec Arensberg et Duchamp. Seconde exposition individuelle à la Daniel Gallery.

Exposition de la Society of Independent Artists à New York. Man Ray réalise des aérographes, c'est-à-dire des peintures au pistolet. Le photographe américain Alvin Langdon Coburn [1882–1966] commence à créer des « vortographes » à Londres.

Troisième exposition individuelle à la Daniel Gallery, comprenant notamment des aérographes. Man Ray se sépare d'Adon Lacroix.

Fonde avec Duchamp et Katherine Dreier [1877–1952] la Société Anonyme, premier musée entièrement consacré à l'art moderne. Commence à travailler en indépendant pour la revue Harper's Bazaar. Exposition de ses photographies au Salon Dada : Exposition Internationale, qui se tient à Paris.

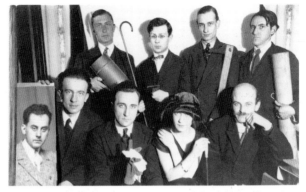

Man Ray
1920

Dada group. Above, l. to r.: *Paul Chadourne, Tristan Tzara, Philippe Soupault, Serge Chadourne*. Below, l. to r.: *Man Ray, Paul Éluard, Jacques Rigaut, Mick Soupault, Georges Ribemont-Dessaignes*
1922

1921]

With Duchamp, publishes the sole issue of *New York Dada*. Duchamp leaves for Paris in June; Man Ray is able to follow in July. Duchamp introduces him to the Paris Dadaists, whom he photographs. Has a one-man show at Librairie Six. Meets and photographs Kiki [Alice Prin, 1901–53], who soon moves in with him.

1922]

Decides to support himself by becoming a portrait photographer; begins to receive attention for his pictures of cultural luminaries. Tries his hand at fashion photography for designer Paul Poiret [1879–1944]. Makes first rayographs [cameraless photographs]. Feature on rayographs in November issue of *Vanity Fair*. Publication of *Champs délicieux*, a limited edition album of twelve rayo-

Zusammen mit Duchamp veröffentlicht er die einzige Ausgabe der Zeitschrift *New York Dada*. Duchamp reist im Juni nach Paris ab; Man Ray folgt ihm im Juli nach. Duchamp führt ihn in den Kreis der Pariser Dadaisten ein, die er fotografiert. Einzelausstellung in der Librairie Six. Er lernt Kiki [Alice Prin, 1901–1953] kennen, die er fotografiert und die bald zu ihm zieht.

Er verdient seinen Lebensunterhalt als Porträtfotograf und gewinnt Anerkennung für seine Aufnahmen von prominenten Persönlichkeiten. Der Couturier Paul Poiret [1879–1944] engagiert ihn als Modefotografen. Die ersten Rayografien [ohne Kamera gefertigte Fotografien] entstehen. Beitrag über Rayografien in der Novemberausgabe von *Vanity Fair*. Er veröffentlicht *Champs délicieux*, ein

Il publie avec Duchamp le seul numéro de la revue *New York Dada*. Duchamp part pour Paris en juin; Man Ray le suit en juillet. Il est présenté par Duchamp aux dadaïstes parisiens qu'il prend en photo. Exposition individuelle à la Librairie Six. Rencontre Kiki [de son vrai nom Alice Prin, 1901–1953]. Il la photographie et ils se mettent bientôt en ménage.

Man Ray décide de gagner sa vie en se spécialisant dans la photographie de portrait ; il commence à attirer l'attention par ses clichés de sommités. Il s'essaie à la photographie de mode pour le couturier Paul Poiret [1879–1944] et réalise ses premières rayographies [photographies sans appareil]. Article sur les rayographies dans le numéro de novembre de *Vanity Fair*. Publication des *Champs*

178

graphs with a preface Tristan
Tzara [1896–1963].

1923]
Abbott becomes his darkroom
assistant until 1926. Publishes
rayographs in the March issue
of *Broom*, for which he designs
the cover, and in the Dada
journal *Littérature*.

1924]
André Breton [1896–1966]
publishes Manifesto of Surrea-
lism. *Le Violon d'Ingres* pub-
lished in *Littérature*. Fashion
photographs appear in French
and American editions of *Vogue*.

1925]
Participates in the first exhibi-
tion of Surrealist art at the
Galerie Pierre, Paris.

1926]
One-man exhibition at the
Galerie Surréaliste. *Société Ano-
nyme* exhibition at the Brooklyn
Museum.

1927]
Travels to New York for an
exhibition of his work at the
Daniel Gallery.

1929]
Meets Lee Miller [1907–77],
who becomes his assistant and
lover until 1932. One-man
show at the Chicago Arts Club.

1930]
Monograph on Man Ray
published in Paris by the
Dadaist Georges Ribemont-
Dessaignes.

Album mit zwölf Rayografien
und einem Vorwort von Tristan
Tzara [1896–1963].

Berenice Abbott wird seine
Dunkelkammerassistentin [bis
1926]. In der Märzausgabe von
Broom, für die er das Titelblatt
gestaltet, und in der Dada-Zeit-
schrift *Littérature* veröffentlicht
er Rayografien.

André Breton [1896–1966]
publiziert sein erstes Manifest
des Surrealismus. *Le violon
d'Ingres* wird in *Littérature* ver-
öffentlicht. Modefotografien in
französischen und amerikani-
schen Ausgaben von *Vogue*.

Er nimmt an der ersten Aus-
stellung surrealistischer Kunst
in der Galerie Pierre, Paris, teil.

Einzelausstellung in der Galerie
Surréaliste. Teilnahme an der
von der *Société Anonyme* organi-
sierten Ausstellung im Brooklyn
Museum, New York.

Zu einer Ausstellung seiner
Werke in der Daniel Gallery
reist er nach New York.

Er lernt Lee Miller [1907–1977]
kennen, die seine Assistentin
und Geliebte wird [bis 1932].
Einzelausstellung im Chicago
Arts Club.

Der Dadaist Georges Ribe-
mont-Dessaignes veröffentlicht
in Paris eine Monographie über
Man Ray.

délicieux, album de douze rayo-
graphies, préfacé par Tristan
Tzara [1896–1963].

Berenice Abbott devient son
assistante jusqu'en 1926 et tra-
vaille pour lui dans la chambre
noire. Publication de rayogram-
mes dans le numéro de mars de
Broom, dont il conçoit la cou-
verture, et dans la revue dada
Littérature.

Parution du premier Manifeste
du surréalisme d'André Breton
[1896–1966]. Parution de *Le
Violon d'Ingres* dans la revue
Littérature. Parution de photo-
graphies de mode dans les édi-
tions française et américaine de
Vogue.

Participation à la première
exposition d'art surréaliste à la
Galerie Pierre à Paris.

Exposition individuelle à la
Galerie Surréaliste. Participa-
tion à l'exposition de la *Société
Anonyme* au musée de Brook-
lyn.

Man Ray se rend à New York
pour une exposition de son
œuvre à la Daniel Gallery.

Rencontre Lee Miller [1907–
1977], qui sera son assistante et
sa maîtresse jusqu'en 1932.
Exposition individuelle au Chi-
cago Arts Club.

Publication à Paris d'une mono-
graphie sur Man Ray, signée
par l'écrivain dadaïste Georges
Ribemont-Dessaignes.

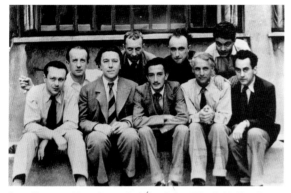

Surrealist group. Above, l. to r.: *Paul Éluard, Jean [Hans] Arp, Yves Tanguy, René Crevel.* Below, l. to r.: *Tristan Tzara, André Breton, Salvador Dalí, Max Ernst, Man Ray* 1930

Paul Outerbridge: *Man Ray*
1926

1931]

Publication of *Électricité*, a portfolio of ten gravure prints of rayographs commissioned by the Paris electric company CPDE [Compagnie Parisienne de Distribution d'Électricité].

1932]

Work included in the *Surrealist Exhibition* at the Julien Levy Gallery, New York.

1934]

Publication of *Photographs by Man Ray 1920 Paris 1934*, with 105 pictures by the artist.

1935]

One-man exhibition of photographs at the Watsworth Atheneum in Hartford, Connecticut. Publication of *Facile*, poems by Paul Éluard [1895–1952] with thirteen photographs by Man Ray. Publishes "Sur le réalisme photogra-

Veröffentlichung von *Electricité*, einer Mappe mit zehn im Tiefdruckverfahren vervielfältigten Rayografien, die die Pariser Elektrizitätsgesellschaft CPDE [Compagnie Parisienne de Distribution d'Électricité] in Auftrag gegeben hatte.

Er beteiligt sich an der *Surrealist Exhibition* in der Julien Levy Gallery, New York.

Veröffentlichung von *Photographs by Man Ray 1920 Paris 1934* mit 105 Fotografien von Man Ray.

Einzelausstellung von Fotografien im Watsworth Atheneum in Hartford, Connecticut. Veröffentlichung von *Facile*, einem Gedichtband mit Paul Éluard [1895–1952] mit 13 Fotografien von Man Ray. In *Cahiers d'art* veröffentlicht er den Beitrag

Publication d'*Electricité*, recueil de dix gravures de rayographies commandé par la Compagnie Parisienne de Distribution d'Électricité [CPDE].

Participation à la *Surrealist Exhibition* qui a lieu à la Julien Levy Gallery à New York.

Publication de *Photographs by Man Ray 1920 Paris 1934*, comprenant 105 photographies de l'artiste.

Exposition individuelle de photographies au Watsworth Atheneum de Hartford, dans le Connecticut. Publication de *Facile*, recueil de poèmes de Paul Éluard [1895–1952] accompagné de treize photographies de Man Ray. Publie « Sur

180

phique" [On photographic realism] in *Cahiers d'art*.

1936]
Buys a small house in Saint-Germain-en-Laye. Begins relationship [lasting until 1940] with Adrienne Fidelin [Ady]. Work shown in the *International Surrealist Exhibition* in London. Attends opening of *Fantastic Art, Dada, Surrealism* at the Museum of Modern Art, New York, exhibiting his own work in many media.

1937]
Publishes *La photographie n'est pas l'art* [Photography is not art].

1938]
Participates in *Exposition internationale du surréalisme* at the Galerie des Beaux-Arts, Paris.

1940]
Leaves Europe for New York after the German occupation of Paris. After a short time there, travels to Los Angeles. Meets Juliet Browner [1911–1991] after a few days in Hollywood; the two soon take up residence together.

1941]
One-man exhibition at Frank Perls Gallery in Hollywood. Publishes "Art in Society" in *California Arts and Architecture*.

»Sur le réalisme photographique« [Über den fotografischen Realismus].

Er kauft ein kleines Haus in Saint-Germain-en-Laye und geht eine Beziehung mit Adrienne Fidelin [Ady] ein, die bis 1940 andauert. Er beteiligt sich an der *International Surrealist Exhibition* in London. Er reist nach New York zur Eröffnung der Ausstellung *Fantastic Art, Dada, Surrealism* im Museum of Modern Art, an der er beteiligt ist.

Er veröffentlicht *La photographie n'est pas l'art* [Die Fotografie ist keine Kunst].

Er nimmt an der *Exposition internationale du surréalisme* in der Galerie des Beaux-Arts in Paris teil.

Nach der Besetzung von Paris durch deutsche Truppen emigriert er nach New York, von wo aus er nach Los Angeles reist. Kurz nach seiner Ankunft lernt er in Hollywood Juliet Browner [1911–1991] kennen, mit der er bald darauf zusammenzieht.

Einzelausstellung in der Frank Perls Gallery in Hollywood. In der Zeitschrift *California Arts and Architecture* veröffentlicht er den Beitrag »Art in Society«.

le réalisme photographique » dans les *Cahiers d'art*.

Man Ray achète une petite maison à Saint-Germain-en-Laye. Il entame une liaison [qui durera jusqu'en 1940] avec Adrienne Fidelin [dite Ady]. Participation à l'*International Surrealist Exhibition* qui s'ouvre à Londres. Inauguration de l'exposition *Fantastic Art, Dada, Surrealism* au Museum of Modern Art de New York, où il est représenté par des œuvres appartenant à plusieurs genres.

Publie *La photographie n'est pas l'art*.

Participation à l'*Exposition internationale du surréalisme* à la Galerie des Beaux-Arts à Paris.

Man Ray quitte l'Europe pour New York après l'occupation de Paris par les Allemands, puis part pour Los Angeles. Rencontre Juliet Browner [1911–1991] quelques jours après son arrivée à Hollywood. Ils emménagent ensemble.

Exposition individuelle à la Frank Perls Gallery de Hollywood. Publication de « Art in Society » dans la revue *California Arts and Architecture*.

1942]

Exhibition of portrait photographs at Frank Perls Gallery. Photographs the author Henry Miller [1891–1980].

Ausstellung von Porträtfotografien in der Frank Perls Gallery. Er fotografiert den Schriftsteller Henry Miller [1891–1980].

Exposition de photographies de portraits à la Frank Perls Gallery. Man Ray photographie Henry Miller [1891–1980].

1943]

Publishes "Photography Is Not Art" in *View*. A selection of five photographs appears in *Minicam Photography*.

In *View* veröffentlicht er den Beitrag »Photography Is Not Art«. In *Minicam Photography* erscheint eine Auswahl von fünf Fotografien.

Publication de « Photography Is Not Art» dans *View*. Reproduction d'un choix de cinq photographies dans *Minicam Photography*.

1944]

Retrospective exhibition at the Pasadena Art Institute.

Retrospektive im Pasadena Art Institute.

Rétrospective de son œuvre à l'Art Institute de Pasadena.

1945]

One-man exhibition at the Los Angeles Museum of History, Science, and Art. Solo exhibition at the Julien Levy Gallery, New York. Resumes connection with *Société Anonyme*.

Einzelausstellung im Museum of History, Science, and Art in Los Angeles. Einzelausstellung in der Julien Levy Gallery, New York. Er nimmt die Verbindung mit der *Société Anonyme* wieder auf.

Exposition individuelle au Museum of History, Science, and Art de Los Angeles. Autre exposition individuelle à la Julien Levy Gallery à New York. Man Ray reprend contact avec la *Société Anonyme*.

1946]

Marries Juliet Browner in a double ceremony with Max Ernst [1891–1976] and Dorothea Tanning [b. 1910].

Doppelhochzeit in Beverly Hills: Man Ray heiratet Juliet Browner, Max Ernst [1891–1976] Dorothea Tanning [geb. 1910].

Man Ray épouse Juliet Browner, et Max Ernst [1891–1976] épouse Dorothea Tanning [née en 1910] lors d'une cérémonie commune.

1947]

Man Ray visits France to secure his goods.

Man Ray reist nach Frankreich, um sich um seine dort zurückgelassene Habe zu kümmern.

Man Ray se rend en France pour entreposer ses affaires.

1948]

Uses photographs of mathematical objects as basis for *Shakespearean Equations*, a series of paintings. One-man show opens at the William Copley Gallery in Beverly Hills. Awarded honorary Master of Fine Arts degree by Fremont University, Los Angeles.

Auf der Grundlage von Fotografien mathematischer Modelle entsteht die Gemäldeserie *Shakespearean Equations* [Shakespearesche Gleichungen]. Einzelausstellung in der William Copley Gallery in Beverly Hills. Die Fremont University, Los Angeles, verleiht ihm ehrenhalber den Titel eines Master of Fine Arts.

S'inspire de photographies d'objets mathématiques pour créer une série de tableaux intitulée *Shakespearean Equations* [Les Équatations de Shakespeare]. Exposition individuelle à la William Copley Gallery à Beverly Hills. Obtention d'une maîtrise honorifique en arts plastiques [honorary Master of Fine Arts degree] à la Fremont University de Los Angeles.

1951]

With Juliet, relocates to Paris.

1952-1957]

Exhibits work in Los Angeles and Paris.

1958]

Commissioned by Polaroid to work with their black-and-white film, resulting in the series *Unconcerned Photographs*. Experiments with color photography.

1959-1960]

Exhibits work in Los Angeles, Paris, New York, and London.

1961]

Awarded a gold medal for photography at the Venice Photo Biennale.

1962]

Retrospective exhibition at the Bibliothèque Nationale, Paris.

1963]

Publication of autobiography, *Self Portrait*. Exhibition of rayographs in Stuttgart.

1964-1965]

Exhibition of 31 *Objects of My Affection* in Italy and New York.

1966]

Retrospective exhibition at the Los Angeles County Museum of Art. Publishes *Résurrection des mannequins* [Resurrection of the Mannequins].

Er zieht mit Juliet wieder nach Paris.

Ausstellungen in Los Angeles und Paris.

Aus seinen Experimenten mit Polaroid-Schwarzweißfilmen geht die Folge *Unconcerned Photographs* [Unbeteiligte Fotografien] hervor. Er experimentiert mit der Farbfotografie.

Ausstellungen in Los Angeles, Paris, New York und London.

Auf der Biennale von Venedig wird er mit der Goldmedaille für Fotografie ausgezeichnet.

Retrospektive in der Bibliothèque Nationale, Paris.

Er veröffentlicht seine Autobiographie *Self Portrait*. Ausstellung von Rayografien in Stuttgart.

In Italien und New York werden 31 *Objects of My Affection* [Objekte meiner Zuneigung] ausgestellt.

Retrospektive im Los Angeles County Museum of Art. Er veröffentlicht *Résurrection des mannequins* [Auferstehung der Mannequins].

Retour à Paris avec Juliet.

Expositions à Los Angeles et à Paris.

Chargé par la firme Polaroid de travailler avec ses pellicules en noir et blanc. Cette commande aboutit à la série *Unconcerned Photographs* [Photographies étrangères]. Effectue des expériences sur la photographie en couleurs.

Expositions à Los Angeles, Paris, New York et Londres.

Reçoit la médaille d'or à la Biennale de photographie de Venise.

Rétrospective de son œuvre à la Bibliothèque Nationale à Paris.

Publication de son autobiographie, *Self Portrait*. Exposition de rayographies à Stuttgart.

Exposition de 31 *Objects of My Affection* [Objets de mon affection] en Italie et à New York.

Rétrospective de son œuvre au Los Angeles County Museum of Art. Publication du livre *Résurrection des mannequins*.

1967]
Awards Committee of the Philadelphia Arts Festival recognizes Man Ray for his accomplishments and the honor reflected upon his native city.

Das Preiskomitee des Philadelphia Arts Festival würdigt Man Ray als verdienstvollen Sohn der Stadt.

Le jury du Festival des arts de Philadelphie récompense Man Ray pour son œuvre et le rayonnement de sa ville natale auquel il a ainsi contribué.

1968]
Work included in two exhibitions at the Museum of Modern Art, New York: *Dada, Surrealism, and their Heritage* and *The Machine as Seen at the End of the Mechanical Age.*

Beteiligung an zwei Ausstellungen im Museum of Modern Art, New York: *Dada, Surrealism, and their Heritage* und *The Machine as Seen at the End of the Mechanical Age.*

Présentation d'œuvres diverses dans deux expositions au Museum of Modern Art à New York : *Dada, Surrealism, and their Heritage* et *The Machine as Seen at the End of the Mechanical Age.*

1970]
Oggetti d'affezione [Objects of my affection] published.

Oggetti d'affezione [Objekte meiner Zuneigung] wird veröffentlicht.

Publication d'*Oggetti d'affezione* [Objets de mon offiction].

1971]
Traveling retrospective exhibition shown in Rotterdam, Paris, and Humlebaek, Denmark.

Retrospektive in Rotterdam. Weitere Stationen: Paris und Humlebaek, Dänemark.

Une rétrospective de son œuvre est présentée successivement à Rotterdam, Paris et Humlebaek, au Danemark.

1972]
Exhibition *Man Ray* shown at the Musée national d'art moderne in Paris.

Ausstellung *Man Ray* im Musée national d'art moderne in Paris.

Exposition *Man Ray* au Musée national d'art moderne à Paris.

1974]
Eighty-fifth birthday exhibition held at the Cultural Center, New York.

Ausstellung anläßlich seines 85. Geburtstags im Cultural Center, New York.

Exposition célébrant les quatre-vingt-cinq ans de l'artiste au Cultural Center de New York.

1976]
Dies in Paris on November 18.

Man Ray stirbt am 18. November in Paris.

Le 18 novembre, Man Ray meurt à Paris.

Man Ray was the most inventive photographic artist of the 20th century. His creative mind gave us solarization, the rayograph, the artistic use of optical surface manipulation and the pairing of positive and negative prints, not to mention his play on words in titles with his surrealistic and Dada vocabulary. He also gave the photographic art market a first wake-up call when fraudulent dating of prints from his negatives surfaced in the early nineties. His disinterest in precise authentication, selection and cropping of his prints made from his negatives – with or without his supervision – by several print makers, whom he entrusted with his print-making after returning to Paris in 1951, will continue to haunt historians and collectors alike. As one of his dealers once noted, Man Ray was play-ful in confusing precise information on so many aspects of his life and work and was pleased to tell one fact about a particular situation to a visi-tor in the morning and something else to another visitor in the afternoon.

Man Ray enjoyed a widely published interest in his work – not only during his lifetime but continuing after his death in 1976. During the research for this project I came across a variety of titles, dates and image croppings for the same negative and reproduced in different books and publications. The Man Ray estate today is not set up to shed light on these varieties and it goes without saying that this publication – though using all reliable sources of information – will not resolve all the problems inherent to this aspect of Man Ray's work. His titles are very often as unique as the work itself, frequently depicting the uniqueness of the French language and its erotic and poetic ambiguities. In those instances we have kept the original French titles without translation.

There are two foremost institutions associated with the work of Man Ray because of their vast holdings of original prints: the J. Paul Getty Museum in Los Angeles and the Musée national d'art moderne Centre Georges Pompidou in Paris, which since 1994 is also home of Man Ray's negatives. I am particularly grateful to Weston Naef, Cura-tor of Photographs at the Getty Museum, who – as always – was ex-tremely helpful in my pursuit and gave me excess to the museum's hold-ings. I am also thankful to Katherine Ware, for contributing to this

project. The staff of the Getty Museum, in particular Julian Cox, Jacklyn Burns, and Ellen Rosenbery, who were very helpful in providing the necessary information and reproductions from the museum material, must be given credit for their thorough efforts. My sincerest thanks goes to Alain Sayag, Curator of Photography at the Centre Pompidou and Emmanuelle de l'Ecotais who curated the monumental Man Ray retrospective exhibition in Paris in 1998 and co-authored its accompanying catalog. I am very pleased indeed and indebted to Emmanuelle de l'Ecotais for writing the outstanding essay on Man Ray's time in Paris, and to Alain Sayag who organized the reproduction material for the selected images from the Centre Pompidou's collection.

I am especially indebted to Gert Elfering, Miamy Beach and Michael Senft, New York, for their willingness to provide reproduction material from their extensive collections. A large number of the images reproduced in this book were scanned directly from original prints from the collection of Gert Elfering, thereby enhancing the technical quality for printing. Alain Paviot, Paris, provided reproduction material of important works from his collection and Virginia L. Green, New York, made reproductions available from her copy of *Mr. and Mrs.Woodman*. Without the cooperation of all these friends and associates this publication would not have been possible.

As always with a series like this one the editorial department at TASCHEN, Simone Philippi, Anja Lenze and especially Bettina Ruhrberg, together with the production teams at NovaConcept, Juliane Winkler and Jonas Kirchner, and at DruckConcept, Dieter Kirchner and particularly Christiane Rothe, were tremendously helpful and supportive throughout this project. Without the dedication and resourcefulness of this professional team I would not have been able to continue the enjoyable work of editing this series.

Manfred Heiting

Man Ray ist der wichtigste Innovator der künstlerischen Fotografie des 20. Jahrhunderts. Sein kreativer Geist schenkte uns die Solarisation, die Rayografie, die künstlerische Bearbeitung von optischen Oberflächen und die Kombination von Positiv- und Negativabzügen, ganz zu schweigen von den Wortspielen in seinen Titeln mit ihrem dadaistischen und surrealistischen Vokabular. Außerdem rief er auf dem Fotografie-Kunstmarkt Anfang der 90er Jahre das Bewußtsein für die betrügerische Falschdatierung der Abzüge von seinen Negativen wach, weil er selbst kein Interesse am Echtheitsnachweis seiner Arbeiten hatte. Nach seiner Rückkehr nach Paris im Jahre 1951 überließ er Auswahl und Ausschnitt der Abzüge von seinen Negativen – ob mit oder ohne seine Überwachung – sehr oft verschiedenen Fotolaboranten. Wie einer seiner Händler einmal bemerkte, ging Man Ray sehr spielerisch mit Informationen um, die so viele Aspekte seines Lebens und seines Werkes betrafen. Er liebte es, Verwirrung zu stiften. Besonderen Gefallen fand er daran, einem Besucher am Morgen zu einer bestimmten Situation eine Erklärung zu geben und nachmittags einem anderen Besucher eine ganz andere.

Nicht nur zu Lebzeiten, sondern ungemindert auch nach seinem Tod im Jahre 1976 erfreute sich Man Rays Werk eines weitverbreiteten Interesses. Während meiner Nachforschungen für dieses Buch stieß ich auf eine Vielzahl von Titeln, Datierungen und Ausschnitten ein und desselben Negativs, die in verschiedenen Büchern und Publikationen reproduziert waren. Der Nachlaß des Künstlers bringt nicht immer Aufklärung in diese Verwirrung. Trotz Ausnutzung aller verläßlicher Quellen haben wir nicht alle Probleme lösen können, die mit diesem Aspekt von Man Rays Werk verbunden sind. Seine Titel sind häufig genau so einmalig wie die Werke selbst. Sie illustrieren in vieler Hinsicht die Einzigartigkeit der französischen Sprache mit ihrer erotischen und poetischen Vieldeutigkeit. Darum haben wir die französischen Originaltitel ohne Übersetzung beibehalten.

Es gibt zwei herausragende Institutionen für das Werk von Man Ray, weil sie einen großen Bestand an Originalabzügen besitzen: Das J. Paul Getty Museum in Los Angeles und das Musée national d'art moderne Centre Georges Pompidou in Paris, wo sich seit 1994 auch Man Rays Negative befinden. Besonders dankbar bin ich Weston Naef,

dem Kurator für Fotografie am Getty Museum, der mir – wie immer – äußerst hilfreich bei meinen Nachforschungen zur Seite gestanden hat und mir den Zugang zu den Museumsbeständen ermöglichte. Ebenso dankbar bin ich Katherine Ware, die einen wichtigen Beitrag zu diesem Projekt geleistet hat. Dank für all ihre Bemühungen gebührt auch den Mitarbeitern des Getty Museum, vor allem Julian Cox, Jacklyn Burns und Ellen Rosenbery, die stets behilflich waren, die Informationen und Reproduktionen aus den Museumsbeständen zu beschaffen. Mein herzlichster Dank gilt Alain Sayag, dem Kurator für Fotografie am Centre Pompidou, und Emmanuelle de l'Ecotais, die gemeinsam die großartige Man-Ray-Retrospektive 1998 in Paris kuratierten und den Katalog herausgaben. Ich bin Emmanuelle de l'Ecotais sehr dankbar für den ausgezeichneten Essay über Man Rays Pariser Zeit und Alain Sayag ebenso dafür, daß er das Reproduktionsmaterial für die Bilder, die aus der Sammlung des Centre Pompidou stammen, bereitgestellt hat.

Besonderen Dank schulde ich Gert Elfering, Miami Beach, und Michael Senft, New York, für ihre Bereitschaft, Abbildungsmaterial aus ihren umfangreichen Sammlungen zur Verfügung zu stellen. Eine große Zahl von Bildern konnte direkt von den Originalabzügen aus der Sammlung Gert Elferings gescannt werden, wodurch die Druckqualität wesentlich verbessert werden konnte. Alain Paviot, Paris, hat Material zur Reproduktion von bedeutenden Werken aus seiner Sammlung zur Verfügung gestellt, und Virginia L. Green, New York, hat Reproduktionen ihrer Kopie von *Mr. and Mrs. Woodman* ermöglicht. Ohne die Mitarbeit all dieser Freunde und Kollegen wäre dieses Buch nicht zustande gekommen.

Wie immer bei der Herausgabe einer Serie wie dieser war das gesamte Lektorat bei TASCHEN, Simone Philippi, Anja Lenze und vor allem Bettina Ruhrberg, eine enorme Hilfe; auch das Herstellungsteam von NovaConcept in Berlin, Juliane Winkler und Jonas Kirchner, und das Team bei DruckConcept, Dieter Kirchner und besonders Christiane Rothe, waren stets mit ihrer Unterstützung zur Stelle. Ohne den Einsatz, das Können und die Findigkeit dieses Teams wäre ich nicht in der Lage gewesen, die schöne Arbeit an der Herausgabe dieser Serie fortzuführen.

Manfred Heiting

Man Ray fut l'artiste photographe le plus inventif du XXe siècle, et sans doute l'esprit le plus créatif dans ce domaine. On lui doit la solarisation, le rayogramme, la manipulation des surfaces optiques à des fins artistiques, le couplage des épreuves positive et négative et, dans le titre de ses œuvres, une foule de jeux de mots qu'il fabriquait à l'aide de son vocabulaire dada et surréaliste. On lui doit aussi d'avoir, pour la première fois, tiré de sa torpeur le marché de l'art photographique lorsque, au début des années 1990, on s'avisa que la datation portée sur certains tirages était frauduleuse. Longtemps, les historiens et les collectionneurs seront hantés par son manque d'intérêt pour la précision de l'authentification, de la sélection et du recadrage des épreuves qu'ils obtinrent, sous sa surveillance ou non, plusieurs laboratoires photo auxquels il confia le soin de développer ses négatifs après son retour à Paris en 1951. Comme un de ses marchands en fit un jour la remarque, il s'amusait à brouiller les pistes sur de très nombreux aspects de sa vie et de son œuvre, et, entre le matin et l'après-midi, il aimait donner des renseignements contradictoires à différents visiteurs.

L'œuvre de Man Ray a fait l'objet d'un vif intérêt éditorial, non seulement de son vivant mais aussi après sa mort en 1976. Au cours des recherches que j'ai effectuées pour ce travail, je me suis rendu compte que le titre, la date et le cadrage de certaines photographies pouvaient changer considérablement d'une publication à une autre. Aujourd'hui encore, la succession de Man Ray n'est pas prête à faire la lumière sur ces disparités, et il va sans dire que le présent ouvrage, même s'il a mis à profit toutes les sources d'information fiables, ne résout pas tous les problèmes liés à cette dimension de son œuvre. Le titre des œuvres est souvent aussi unique que les œuvres elles-mêmes. Nombreux sont ceux qui n'ont de sens qu'en français, avec toutes les ambiguïtés érotiques et poétiques dont la langue peut être porteuse. Le cas échéant, nous les avons donc conservés dans la langue originale sans les traduire.

Deux institutions majeures, en raison du très grand nombre d'originaux qu'elles possèdent, sont associées à l'œuvre de Man Ray : le musée J. Paul Getty de Los Angeles et le Musée national d'art moderne du Centre Georges Pompidou à Paris, qui abrite également, depuis 1994, les négatifs de l'artiste. Au musée Getty, ma reconnaissance va tout d'abord à Weston Naef, conservateur du département photographique :

comme toujours, il m'a été d'une aide extrêmement précieuse dans mes recherches et il m'a donné accès au fonds du musée. Je remercie également Katherine Ware d'avoir participé au projet. Parmi le personnel, je ne saurais omettre Julian Cox, Jacklyn Burns et Ellen Rosenbery, qui se sont aimablement efforcés de me communiquer les renseignements nécessaires et les reproductions des documents du musée. J'exprime mes plus vifs remerciements à Alain Sayag, conservateur du département photographique du Centre Georges Pompidou, ainsi qu'à Emmanuelle de l'Ecotais, commissaire de la gigantesque rétrospective Man Ray à Paris en 1998, et co-responsable du catalogue de cette exposition. C'est avec plaisir que je témoigne ma gratitude à Emmanuelle de l'Ecotais, qui a écrit le texte remarquable sur la période parisienne de Man Ray, et à Alain Sayag, qui a organisé la reproduction des images sélectionnées dans les collections du Centre Georges Pompidou.

Je suis tout particulièrement redevable à Gert Elfering, de Miami Beach, et à Michael Senft, de New York, d'avoir permis la reproduction de certaines pièces de leur vaste collection. Une grande partie de l'iconographie présentée dans l'ouvrage a été directement scannée à partir des épreuves originales que possède Gert Elfering, ce qui a nettement amélioré la qualité technique de l'impression. Alain Paviot, de Paris, a également permis la reproduction d'œuvres importantes de sa collection, et Virginia L. Green, de New York, a fourni des images de *Mr. and Mrs. Woodman*. Sans la coopération de ces amis et collaborateurs, l'ouvrage présent n'aurait pu voir le jour.

Comme toujours dans cette série, le département éditorial des éditions TASCHEN, et en l'occurrence Simone Philippi, Anja Lenze et surtout Bettina Ruhrberg, ainsi que Juliane Winkler et Jonas Kirchner du groupe de production NovaConcept, Dieter Kirchner et surtout Christiane Rothe chez DruckConcept m'ont apporté une aide et un soutien précieux tout au long de l'élaboration de ce livre. Sans le dévouement, l'ingéniosité et le professionnalisme de cette équipe, je n'aurais pu poursuivre le travail passionnant que représente la responsabilité de cette série.

Manfred Heiting

The publishers wish to thank the Museums and Private
Collections for granting permission to reproduce works and
for their support in the making of this book.

Der Verlag dankt den Museen und Privatsammlungen für
die erteilten Reproduktionsgenehmigungen und ihre freund-
liche Unterstützung bei der Realisierung dieses Buches.

La maison d'édition remercie les musées et les collections
privées de leur authorisation pour la reproduction des œuv-
res et de leur aimable soutien lors de la réalisation de ce livre.

THE J. PAUL GETTY MUSEUM, LOS ANGELES:
P. 6|24|56|60|65|69|106|109|138|139|141|144|145|
146|147|149|150|151|156|157|163|170|174|177|179

MUSÉE NATIONAL D'ART MODERNE, CENTRE GEORGES
POMPIDOU:
P. 8|9|46|54|55|99|101|102|103|155|158|159

COLLECTION MICHAEL SENFT, NEW YORK:
P. 10|49|87|91|96|97|110|132|133|134|135|137|152|
162|166|167|168

COLLECTION ALAIN PAVIOT, PARIS:
P. 22|23|27|70|72|73|107|114|171

COLLECTION VIRGINIA L. GREEN, NEW YORK:
P. 118|119|120

G. RAY HAWKINS GALLERY, SANTA MONICA:
P. 179

PRIVATE COLLECTIONS:
P. 2|7|21|25|28|29|31|32|33|34|35|37|38|39|40|41|
42|43|44|45|48|50|51|53|57|58|61|62|63|64|66|68|71|
74|88|89|90|92|94|95|98|100|105|108|111|112|113|
115|117|131|140|143|153|161|165|169|173

© 2001 TASCHEN GmbH
Hohenzollernring 53, D-50672 Köln
www.taschen.com

© 2001 Man Ray Trust, Paris /
VG Bild-Kunst, Bonn

© 2001 Emmanuelle de l'Ecotais, Paris

EDITOR
Manfred Heiting, Amsterdam

DESIGN
Lambert und Lambert, Düsseldorf
Catinka Keul, Cologne

LAYOUT
Manfred Heiting, Amsterdam

COVER DESIGN
Angelika Taschen, Cologne

EDITORIAL COORDINATION
Bettina Ruhrberg, Simone Philippi, Cologne

TRANSLATION
German translation by Wolfgang Himmelberg, Düsseldorf
French translation by Frédéric Maurin, Paris

LITHOGRAPHY
NovaConcept, Berlin

Printed in Italy
ISBN 3-8228-5556-1

"Buy them all and add some pleasure to your life."

Art Now
Eds. Burkhard Riemschneider,
Uta Grosenick

Art. The 15th Century
Rose-Marie and Rainer Hagen

Art. The 16th Century
Rose-Marie and Rainer Hagen

Atget's Paris
Ed. Hans Christian Adam

Best of Bizarre
Ed. Eric Kroll

Karl Blossfeldt
Ed. Hans Christian Adam

Chairs
Charlotte & Peter Fiell

Classic Rock Covers
Michael Ochs

Description of Egypt
Ed. Gilles Néret

Design of the 20th Century
Charlotte & Peter Fiell

Dessous
Lingerie as Erotic Weapon
Gilles Néret

Encyclopaedia Anatomica
Museo La Specola
Florence

Erotica 17th–18th Century
From Rembrandt to Fragonard
Gilles Néret

Erotica 19th Century
From Courbet to Gauguin
Gilles Néret

Erotica 20th Century, Vol. I
From Rodin to Picasso
Gilles Néret

Erotica 20th Century, Vol. II
From Dalí to Crumb
Gilles Néret

The Garden at Eichstätt
Basilius Besler

Indian Style
Ed. Angelika Taschen

London Style
Ed. Angelika Taschen

Male Nudes
David Leddick

Man Ray
Ed. Manfred Heiting

Native Americans
Edward S. Curtis
Ed. Hans Christian Adam

Paris-Hollywood.
Serge Jacques
Ed. Gilles Néret

20th Century Photography
Museum Ludwig Cologne

Pin-Ups
Ed. Burkhard Riemschneider

Giovanni Battista Piranesi
Luigi Ficacci

Redouté's Roses
Pierre-Joseph Redouté

Robots and Spaceships
Ed. Teruhisa Kitahara

Eric Stanton
Reunion in Ropes & Other Stories
Ed. Burkhard Riemschneider

Eric Stanton
She Dominates All & Other
Stories
Ed. Burkhard Riemschneider

Tattoos
Ed. Henk Schiffmacher

Edward Weston
Ed. Manfred Heiting

www.taschen.com

Live

a polemical review
of the performing arts